Design Graphics

Drawing Techniques for Design Professionals

SECOND EDITION

Written and Illustrated by

Peter A. Koenig, IDEC
Florida State University

Upper Saddle River, New Jersey 07458

Library of Congress Cataloging-in-Publication Data

Koenig, Peter A.
 Design graphics : drawing techniques for design professionals / written and illustrated by
Peter A. Koenig.—2nd ed.
 p. cm.
 Includes bibliographical references and index.
 ISBN 0-13-113701-8
 1. Interior decoration rendering—Technique. 2. Architectual drawing—Technique I.
Title.

NK2113.5.K64 2006
720'.28'4—dc22 2004058709

Executive Editor: Vernon R. Anthony
Editorial Assistant: Beth Dyke
Director of Manufacturing and Production: Bruce Johnson
Managing Editor: Mary Carnis
Production Liaison: Janice Stangel
Creative Director: Cheryl Asherman
Manufacturing Manager: Ilene Sanford
Manufacturing Buyer: Cathleen Petersen
Production Editor: Linda Zuk, WordCrafters
Senior Marketing Manager: Ryan DeGrote
Senior Marketing Coordinator: Elizabeth Farrell
Marketing Assistant: Les Roberts
Composition: Carlisle Communications, Ltd.
Cover Designer: Larry Davits
Cover Illustration: Courtesy of Peter A. Koenig
Printer/Binder: Courier-Westford
Cover Printer: Coral Graphics

Pearson Education LTD.
Pearson Education Singapore, Pte. Ltd.
Pearson Education, Canada, Ltd.
Pearson Education—Japan

Pearson Education Australia PTY, Limited
Pearson Education North Asia Ltd
Pearson Educación de Mexico, S.A. de C.V.
Pearson Education Malaysia, Pte. Ltd

10 9 8 7 6 5
ISBN 0-13-113701-8

Design
Graphics

To **donalee,** still my one and only;

Our daughter **Moya;**

Mom, in memoriam, thank you. This one's for you;

Uncle Irv, my biggest fan; and **Aunt Annie**

CONTENTS

Preface ix

Introduction **Drawing** 1

Part One **SKETCHING** 3

1 **The Basics** 9

2 **Line** 19

3 **Light** 31

4 **Texture** 39

Part Two **DESIGN DRAWING** 47

5 **Conceptual Doodle/Diagrams** 51

6 **Perspective Drawing** 63

Part Three **DRAWING PROCESS** 81

7 **One-Point Eyeball Perspective** 89

8 **Two-Point Eyeball Perspective** 101

9 **Overlay Method** 111

10 **Entourage** 131

11 **Presentation** 149

Bibliography 153

Glossary/Index 155

CONTENTS

PREFACE

This book evolved from a course I developed in interior design graphics. I started my career as an interior designer and architectural renderer in New York City in 1969. I first taught graphics for interior designers in 1970. Over the years I have relied on texts by many graphic educators, including Kirby Lockard, Edward T. White, and Paul Leaseau.

A number of choices were available to me as textbooks for my new course, but I soon realized I would need several that covered a great deal of nonrelated material. Most books on graphics attempt to be far too comprehensive and fail to meet specific needs. I then produced a booklet to meet my specific requirements based on my own professional experience and drawings. That booklet evolved into this book.

The three main areas of emphasis in this text are still sketching, design drawing, and the drawing process. These are the most critical areas related to the designer's ability to design and communicate. The text takes a monochromatic approach since color technique is the subject of another course in our graphic series. However, the basics of this text are the foundation for success in color renderings.

The text is intended for interior design students but is pertinent for many other design students and professionals.

Intended as a primer-level book, it shows simple techniques and skills related to sketching, design development, and the schematic or preliminary phase of design presentation. These simple techniques are of great benefit to the professional.

It is ironic that, although this course was developed to recognize the need for and to maintain hand drawing as a design skill, much of the initial layout and formatting was done with the help of the computer. In the age of computer-aided drawing (CAD), it is imperative that graphic communicators keep the skill of hand drawing alive. It has certainly proved to me that the drawing skills of the past can coexist with and be a beneficial part of the computer age. In fact, all of the professionals, architects, and designers I have met since this book was published agree with this concept.

Many thanks for the valuable and enlightening comments from my esteemed colleagues: Ann Kellogg, Illinois Institute of Art; Nancy Kwallek, University of Texas at Austin; Christine Myres, University of Arkansas; David R. Pohl, University of Memphis; Maria Siera, University of Missouri; and Catherine St. John, Berkeley College. Thanks also to Jaime Brock for preparing the Glossary/Index.

I would like to thank David Butler, Bob Burke, Tim White, and Kirby Lockard for their help and inspiration in making this book become a reality. Finally, my grateful appreciation to my students, who have been a major source of feedback to address the needs in this revision.

Peter A. Koenig

Design
Graphics

Introduction

DRAWING

Why do we draw?

The most simplistic answer to this question, clearly, is to communicate. Designers can try to communicate ideas verbally or with the written word, although we should not choose to emulate the poet or the novelist because ours is a visual art form.

Design graphics incorporates sections on sketching, design drawing, and the drawing process. Can these drawing skills be learned? The answer is a definitive YES. Artistic ability is a plus but not a necessity. Rather, a desire to learn and a willingness to practice, practice, practice are the keys to success.

In many cases, an awareness of reality or simply "learning to see" can be our guide. The average person is happy to process seeing into simply not bumping into anything during the course of a day. This, however, is not the level of seeing one expects from a designer. Special concern for relationships, elements, and details is critical to the designer as observer.

In general, the mere act of drawing—physically putting lines and media on a surface—has survived through the ages. Clearly this skill is being threatened in the age of computer-aided drawing. Fortunately, drawing educators across the country not only believe that the skill must be maintained, but also that it is a necessary foundation for the development of design to complement computer-aided activities.

DRAWING FOR FUN

Sometimes designers draw or sketch just for the sheer emotional and physical pleasure of the experience, utilizing the skill of hand/eye coordination.

DRAWING FOR DESIGN

In the preliminary or schematic phase of design, we are able to THINK through the use of our visual shorthand, drawing conceptual/doodle diagrams to examine potential solutions on paper. We draw to:

- *Record our ideas, rather than relying on our memory.*
- *Keep track of the evolution of ideas.*
- *Transfer ideas from our **mind's eye** that do not currently exist in a way that can represent future reality.*
- *Express creativity.*
- *Allow for change before change becomes both costly and prohibitive.*
- *Acquire preliminary and then final client approval.*

DRAWING FOR COMMUNICATION

This is the skill of presenting design ideas, concepts, and solutions to a client. These drawings may vary in scope from sketch—napkin art over lunch—to a full-blown final-board presentation. The design process section of this text examines several presentation alternatives including the overlay method. These methods vary and are always affected by time and budgetary constraints.

Part One
SKETCHING

How do we define sketching?

The art of **sketching** is an expression of a style or technique of freehand drawing. It is a skill generally learned by drawing what you see, relying on the development of hand/eye coordination.

A sketch may be:

- **tight** (Figure P1.2) or **loose** (Figure P1.1),
- **line drawing only** (Figure P1.3), or
- any combination of line, tone/shadow, or texture (Figure P1.4). (Color is not covered in this text.)

Sketching as a technique is taught through exercises that improve the ability to "see" while practicing and improving hand/eye coordination.

For the designer, the primary benefit of sketching skills is truly realized in the schematic or preliminary phase of the design process. This phase includes conceptual/doodle diagrams and image drawings. At this point, fast, loose, sketch-style drawings are a real time-saver.

Sketching as a technique knows no media restrictions; you can use whatever works or is at hand. However, a variety of pencils, pens, and felt-tip pens are still the most popular tools today.

Figure P1.1

**LOOSE SKETCHES, LINE ONLY:
DETAILS FROM ITALY
SKETCHBOOK**

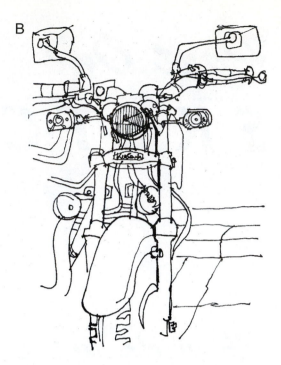

B

A

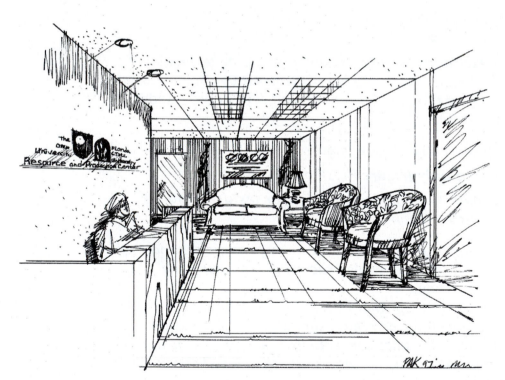

Figure P1.2

**TIGHT SKETCH: FLORIDA STATE UNIVERSITY, DISTANCE
LEARNING RECEPTION AREA; ORIGINAL IS 8 × 10**

SKETCHING **4**

Figure P1.3

LINE WEIGHT VARIATION FROM ITALY SKETCHBOOK

Figure P1.4

COMBINATION OF LINE AND TEXTURE FROM ITALY SKETCHBOOK

Figure P1.5

THUMBNAIL SKETCHES, LESS THAN 3 MINUTES EACH

Figure P1.6

FINISHED DRAWING THAT EVOLVED FROM THUMBNAILS, 4 HOURS

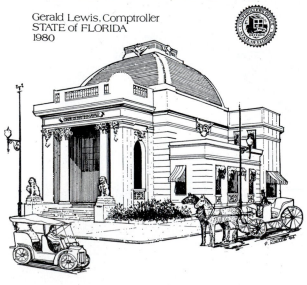

ANNUAL REPORT of the
DIVISION of BANKING

Gerald Lewis, Comptroller
STATE of FLORIDA
1980

You should carry a sketchbook with you at all times because design ideas can come to you in any place and at any time. In fact, I keep one at my bedside in case I wake up with or even dream up a good idea. A good designer's creative process never sleeps. Since it is impossible to remember all of your ideas during a busy day, putting them on paper is a safe way to prevent you from losing a potentially great one. Sizes and types of sketchbooks vary greatly. Choose one that works for you and that you will actually use.

When you are practicing sketching, draw things that already exist and that you can clearly see rather than using your imagination. Select things you want to improve on, and work and concentrate on them exclusively.

Sketches are pieces of information; they don't have to be considered works of art. They have their own innate beauty and should not be compared with more time-consuming types of drawings.

Often sketches have a level of simplicity that allows the viewer's eye to finish the picture. This type of sketch is referred to as a vignette and can save a lot of rendering time.

Sketching is clearly a very valuable design tool that is well worth developing. It can be done in any place and at any time with a minimum amount of equipment and can be used throughout your design career. Often a **thumbnail** *sketch drawn in a matter of minutes is actually very representative of what the final drawing or design turns out to be (see Figures P1.5 and P1.6). Quick sketches done right in front of the client are one of the most helpful means of getting a point across. Once this valuable skill is learned, it becomes part of your design drawing vocabulary.*

SKETCHING

THE BASICS

What materials do I need?

Basic texts often spend much time and effort listing and visually illustrating presentation tools and materials, even going so far as to carefully render a mundane drawing pencil. Since even a brief foray through a good art supply store will provide access to all your needs, the following information is offered simply as a starting point.

Figure 1.1
PENCIL SKETCH OF PENCILS

9

Figure 1.2
ACHIEVING A CHISEL POINT

DRAWING TOOLS

Pencils

A pencil is one of the most versatile tools and is often ignored. The typical drawing pencil is a nonmechanical wood and graphite tool without an eraser. Mechanical, adjustable-lead pencils can be used, but the type of lead they use cannot be **chiseled**. The lead is generally brittle and breaks easily. Keeping a proper point on a pencil is essential to good sketch quality, so keep a pencil sharpener handy or carry a small portable one with you. A chiseled point opens the range of line quality that can be achieved by simply turning the pencil point. The chisel point is achieved by rubbing a sharpened pencil point against a sandpaper block or even just a piece of paper (Figure 1.2).

As mentioned earlier, the typical drawing pencil does not have an eraser. There is a specific reason for this, and it may be more psychological than actual. The rationale is that, because a sketch is a fast, personal expression of an idea or a method of recording what you see, you do not need to fix or correct it, thus eliminating the need for an eraser.

Pencils come in a variety of lead weights, the hardest being 6H and the softest, 6B. The softer leads are more suitable to sketching, while the harder ones are more appropriate for drafting.

Black Felt-, Fiber-, or Nylon-Tip Pens

These pens are very popular sketching tools and have for the most part replaced all forms of refillable technical ink pens. Many of the drawings in this book were drawn with Pilot, Pentel, and Sanford brands of pens (Figure 1.3).

These pens come in a variety of points from micro-fine to broad-tip. The basic broad-tip marker is now offered with several point sizes on the same tool. This is meant to make changes in line simpler to accomplish, although the basic chisel-shaped broad-tip is extremely versatile when used sensitively. Versatility is extremely important since we must consider consistency, weight, and character of lines as they affect all of our drawings.

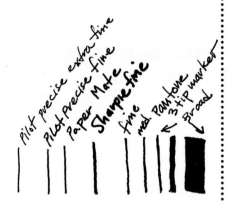

Figure 1.3
VARIETY OF FELT-, FIBER-, AND NYLON-TIP LINE WEIGHTS

Design Markers

The design marker is a fast, economical, and easy-to-maintain medium. I have been rendering with design markers for more than 30 years, and they have remained effectively the same over time with some minor variations in the container and variety of tips—although chemical content was changed after it was found that breathing marker fumes can be hazardous to your health. These tips vary from fine to broad, with some markers offering three or more choices on the same marker. It is my contention that the basic broad-tip marker is by far the most versatile and easy to use. Effective use of markers often depends on some simple choices, such as the paper you use. Parchment tracing paper and sketchbook paper are good for preliminary drawings. But the marker sits on parchment paper and dries slowly, whereas bleeding is a problem with sketchbook paper. Graphics paper is a tracing medium designed for final marker drawing. Following are some suggestions for the use of markers.

LINE. *With the broad-tip marker, turn to the narrow edge for the finest line, the medium edge for mid-range stroke, and the broad side for broadest stroke (see Figure 1.4). For finer lines, I prefer the basic felt-tip pen, but few tools offer the flexibility and versatility of the standard design marker. All brand name markers are basically the same. I make my selection based on color range and comfort of the form of the marker.*

Figure 1.4

MARKER LINE WEIGHT EXAMPLES AND VARIATION

THE BASICS

TONE/SHADOW. *The design marker is especially effective for defining form and space with tone and shadow using the fast sketch technique. Broad areas of a sketch or the final level in a drawing can be covered in a very short time. Here again we find certain marker characteristics that can be particularly frustrating for the beginner. For example, when covering a plane with vertical or horizontal strokes that are not perfectly aligned, you get a linear effect from the overlapping strokes (Figure 1.5). When the effect is controlled, however, it can enhance the vertical movement on a vanishing plane. In addition, overlapping the marker stroke in the same or opposite direction will enable you to get several different values from the same marker. To achieve a **wash,** or more even effect, move the marker stroke in a circular motion (Figure 1.5A, B). Various markers are available that allow you to render in the standard value scale of 0 to 10. Usually, white paper provides the 0 value, with 10 being black.*

Figure 1.5

MARKER STROKE EFFECTS CAN BE USED TO MOVE A VANISHING PLANE

A

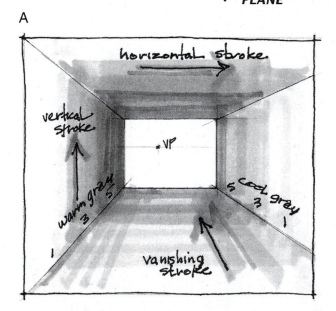

B

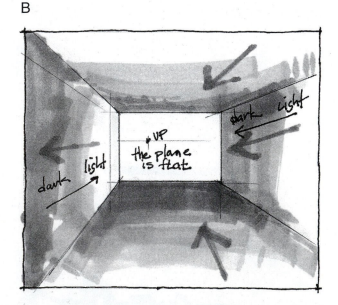

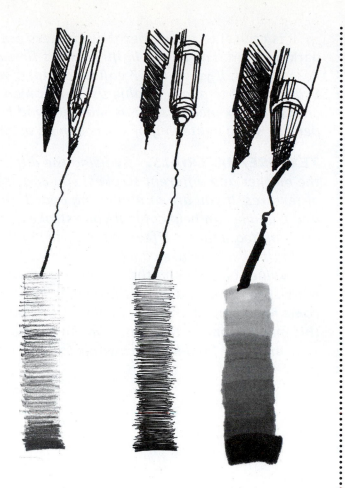

MISCELLANEOUS. *For sketching or rendering, any tool at hand or whatever works for you is acceptable (Figure 1.6). Some other popular choices are colored pencils, pastels, chalks, inks, and even the old standard ballpoint pen (Figure 1.8).*

Sketch exercises often include the use of found objects to encourage the student to loosen up by breaking away from the standard tools. For example, you can use tree twigs, Q-tips, or burnt wood matches dipped in colored water or inks.

It is critical to remember that markers are a light-to-dark medium. *Lay on the lighter values first and build up. For example, if you put a 7 value on paper, you cannot bring it back to a lower value using this medium. If you choose to mix media, such as markers and colored pencils, some lightening of value can be achieved.*

TEXTURE/MATERIALS. *By using the different edges of the marker and different strokes, you can create a variety of textures. If you are at a drafting board, the T-square and triangle can help control your strokes while not creating too tight an effect in the drawing (Figure 1.7).*

In this book we are concerned only with warm and cool values of gray and the role they play in monochromatic studies and drawings. Obviously markers come in a complete range of colors that continue to make this medium one of the most popular for designers in both sketching and final-level drawings for client-oriented presentation.

Figure 1.7

TEXTURE WITH MARKER. MARKER STROKE IN CIRCULAR MANNER (WASH) PRODUCES A SMOOTHER EFFECT; AVOID OVERLAPS

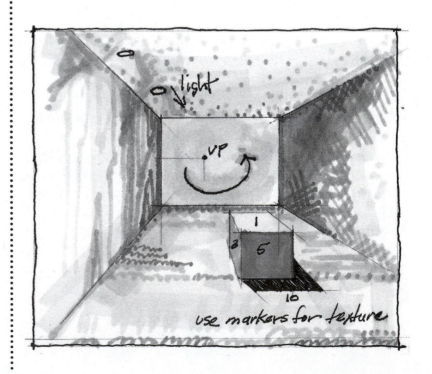

Figure 1.8

SKETCH DONE WITH BLUE BALL POINT PEN

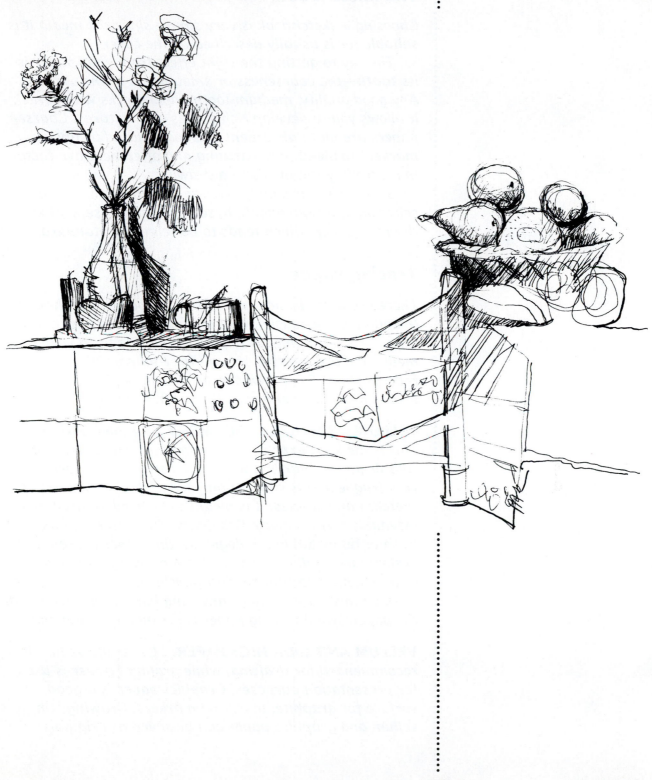

DRAWING PAPER

The Sketchbook

Choosing a sketchbook is very simple since the media it is suitable for is usually described on the cover.

The key to getting the right effect from your paper is its **tooth**—the coarseness or smoothness of the surface. Any good-quality, medium-tooth paper works with pencil. It allows you to develop rich values and textures. Coarser papers are more absorbent and may cause felt tips or markers to bleed, *a frustrating and often negative factor in controlling the media in a drawing.*

So usually it is simply the size that determines the selection of a sketchbook, based on ease of use, rather than the paper, which tends to be relatively standard.

Tracing Paper

There are three basic types of tracing paper: parchment (mentioned previously), vellum, and graphics paper. The latter two are high-quality papers suitable for a variety of media and are durable enough for commercial reproduction. Tracing paper, as we will see later in this text, is a crucial element in the overlay method.

YELLOW OR WHITE PARCHMENT TRACING PAPER. This is the least expensive tracing paper and comes in rolls or pads of varying widths and sizes. The paper is very fragile and is suitable only for preliminary types of sketches and studies. It is meant to be used, abused, and inevitably thrown away. Designers often refer to it as trash or bumwad. Psychologically, this paper is seen as a preliminary medium for fast, loose drawings that are clearly subject to change. Soft pencils and felt-tip pens are ideal on this surface, since anything harder will easily tear the paper. White tracing paper is far more popular today.

VELLUM AND GRAPHICS PAPER. Generally vellum is recommended for drafting, while graphics paper is used for presentation purposes. Graphics paper is a good surface for graphite, inks, and markers. Drawings on vellum and graphics paper can be saved as originals

using a variety of reproduction methods or used in final presentations when mounted properly.

Miscellaneous Papers

A tremendous selection of drawing papers may be purchased by the sheet. I suggest, once again, visiting the art supply store to see and to sample them. Remember, with colored paper, that the 0 value or white needs to be brought back with color pencil, chalk, or paint.

BASIC DRAWING ADVICE

The very first step to success in drawing is to **loosen up**. Drawing, like many athletic activities, is a connection among mind, eye, and hand. Thus, as with all physical activity or exercise, a warm-up phase is suggested. Simple movement of the arms, wrists, and fingers can be effective. When drawing, having tight muscles and joints will have an adverse effect, so remember to be loose, free, and relaxed. This will allow you to enjoy and enhance your drawing experience.

What is line?

Line is the basic element common to all drawings. To the beginner, simply making the first mark that destroys the purity and perfection of the white sheet of paper can instill fear. Remember that this fear is irrational, so be bold and draw away!

In the sketching phase, making lines with mechanical tools, a T-square, and a triangle is not allowed.

A beginner who does not feel that he or she is artistic often exclaims, "I can't even draw a straight line!" We deal with this by stressing that design drawing and sketching can be learned. In fact, in freehand drawing it is the acceptance of the illusion that the line is straight that really counts. Of course, with practice you can achieve relatively straight lines by improving your hand/eye coordination. In the final analysis, the ability to draw a line from point A to point B (Figure 2.1) does not an artist make!

Figure 2.1

DRAW A STRAIGHT LINE IN ONE STROKE

Figure 2.2

DON'T SHAKE OUT THE LINE

When attempting to draw a straight line, rest your hand firmly on a steady surface and move only your hand and forearm across the paper. Avoid what I refer to as shaking out *the line (Figure 2.2)*. Try to draw the line with one bold, confident stroke, rather than stopping and starting to correct for direction. An architectural effect can be achieved by overlapping the line at the corners of a shape or form *(Figure 2.3)*.

Figure 2.3

EXAMPLE OF ARCHITECTURAL OVERLAP

ELEMENTS OF A LINE

The three basic **elements of a line** are consistency, line weight variation, and quality.

Consistency

Practice this effect in a drawing by keeping the lines the same weight (thickness) or character no matter what the subject *(Figure 2.4)*. This is an interesting but limited technique that is more of an exercise of control. It is often used more effectively in technical or mechanical drawing.

Figure 2.4

LINE CONSISTENCY

Figure 2.5
LINE WEIGHT VARIATION

Weight Variation

*Line weight variation adds to the illusion of three-dimensional form. Visually, **line weight** is the thickness of a line. The thinner the line, the lighter the weight. These weight differences help us to distinguish between architectural elements and to define individual forms (Figure 2.5). Lightweight lines usually are internal and help to complete the form. Medium-weight or profile lines define the form and help place it spatially. Heavyweight lines define architectural features or act as base plane lines that help to ground the form (Figure 2.6). The two sketches in Figure 2.7A, B show line weight variation on sketchbook paper.*

Figure 2.6

LINE WEIGHT VARIATION USED TO DEFINE SPACE AND OBJECTS

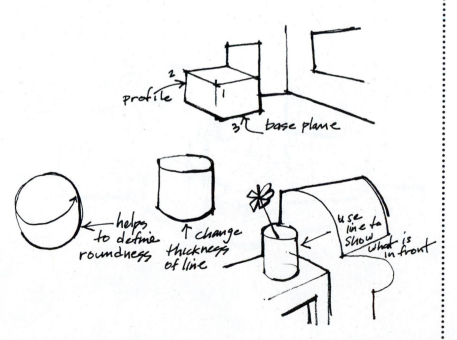

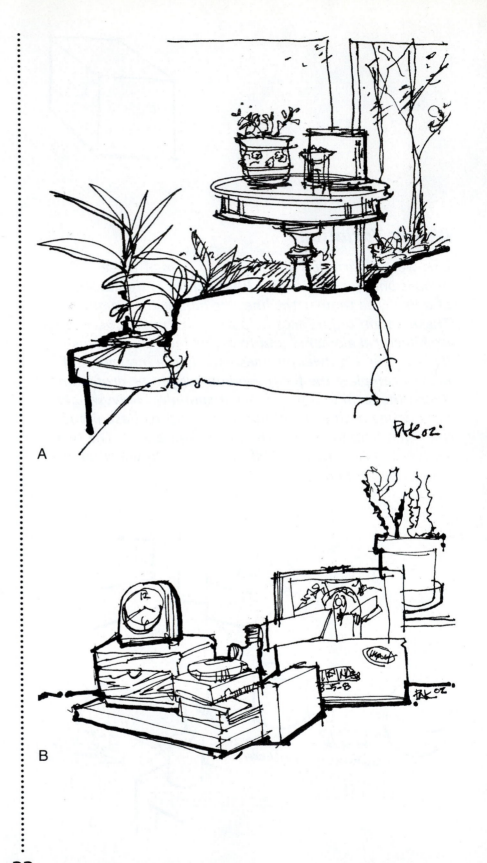

Figure 2.7

SKETCHES WITH LINE WEIGHT VARIATION ON SKETCHBOOK PAPER

A

B

Quality (Character)

Quality is the most expressive use of line, and it truly enhances a sketch's style. Good line quality helps define and make the illusion of curved or round shapes or forms more believable (Figure 2.8). Most often, however, the quality of line is best utilized in freeform objects such as plants, clothing, window coverings, and many other elements typically found in residential or commercial interior or exterior sketches.

Figure 2.8
LINE QUALITY

A

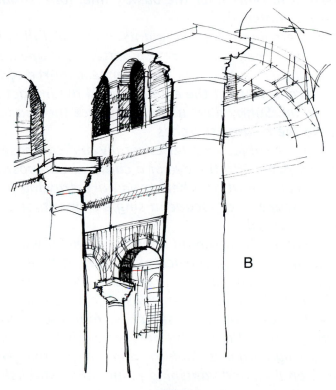

B

C

EXTERIOR SKETCH

Exterior sketching is an excellent way to practice hand/eye coordination while enjoying the outdoors and natural surroundings. You can sketch things you want to record for future reference. You may sketch the architectural elements and features of places you visit, or you can sketch in nature just for the sheer pleasure of doing it.

Whether sketching natural or man-made elements, it is important to remember the basics: line, tone/shadow, and texture/materials.

When sketching trees and plants, look carefully at—"learn to see"—their form, growth patterns, shapes, and textures. Natural sunlight is the strongest source of light and will strongly affect the elements and the impact of your drawing. Sunny days usually produce the shadows that make the boldest sketches.

Select your subject matter carefully and compose your sketchbook page with the eye of a camera. Composition remains a consideration whether you are drawing a major landscape or cityscape, a single element, or even the smallest detail.

As a beginner you should limit the scope of what you choose to draw and keep track of the time it takes you to accomplish what you set out to achieve. Over time, with practice, you will be able to increase the pace and shorten the time it takes to do these sketches. Your knowledge of basic one-point and two-point perspective is important. While drawing outdoors, look for and identify the ground line, horizon line, and vanishing points and establish a picture plane that will increase the illusion of a believable perspective view (Figure 2.9).

Always note the goals you wish to achieve in your sketch exercises; this allows you to measure your success. For example, I sometimes study a building's form using line only. Or I may study the leaf growth pattern of a particular tree.

Set time limits for these sketches from a few minutes to an hour.

Figure 2.9

BUILDING STUDY SKETCH: CAPITOL BUILDING, TALLAHASSEE, LINE ONLY, 10 MINUTES

Figure 2.10
EXTERIOR DETAILS, 5 MINUTES, FROM ITALY SKETCHBOOK

INTERIOR SKETCH

Interior sketch subjects are always available and are not affected by weather conditions. You can study entire rooms in residential and nonresidential situations. You can study furniture relationships; usually a grouping of three objects works well. You can study any interior detail.

You can actually set up a still life to practice drawing specific items that express the shapes, forms, and textures that will offer a challenge. Or go out and look for things that are interesting to practice on.

Figure 2.11
TONE/TEXTURE STUDY

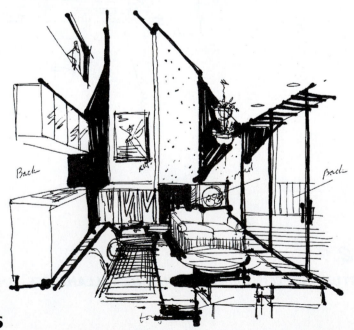

Line Exercises

I. "LOOSEN-UP" EXERCISE

The most informal of the "loosen-up" exercises involves the use of line in a variety of movements across the page. These exercises should be fast paced and should serve only as a warm-up.

Media: sketchbook
 all pencil, pen, felt-tip, etc.

II. LINE CONTROL EXERCISES

1. Basic Line Consistency

Use a variety of vertical, horizontal, and diagonal line directions or vary the spacing while keeping the line a consistent thickness. Control is the key to this exercise.

2. Line Consistency with Variety

Use your imagination to draw loops, swirls, or any other interesting line movements.

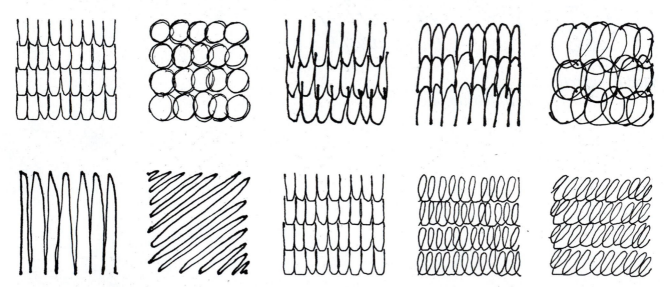

Media: sketchbook
 pencil, felt tip
One or two pages
Size: 1½" x 1½" squares

III. HAND/EYE COORDINATION EXERCISES: STILL LIFE STUDY

This study may be a single object or a complex composition. In the classroom, a good variety of shapes, forms, and textures works best. They may include cans, bottles, purses, jackets, drafting tools, plants, and various found objects. Still lifes improve hand/eye coordination.

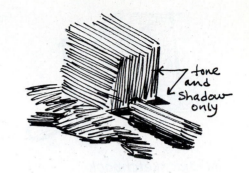

tone and Shadow only

1. Tone/Shadow

Tone/shadow exercises can be done in either interior or exterior locations. In the classroom specifically, setting up a still life works well. A good source of light is very important.

Study the subject for tone and shadow only. Don't outline objects, but use tone to define form and shadow to reinforce the direction and quantity of light. Remember this rule of thumb: Shadow is darker than shade. Do not consider texture or pattern.

2. Texture/Materials

Study texture and materials only; disregard line and light. It is not necessary to draw the entire still life; be selective within the time limit.

Again time is relative, but a minimum of 10 minutes is effective. This exercise can be done in either interior or exterior locations.

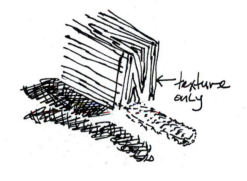

texture only

In the classroom, use the same still life for all of these exercises. The still life must include objects that have clearly definable textures or patterns. Wood, glass, coarse fabrics, and plants are just a few things that work well. Everything has texture, but things with smooth or slick textures don't work as well. You should, however, feel free to use some generic textures such as stippling or crosshatching.

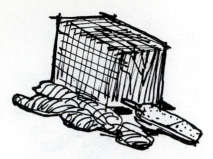

Media: sketchbook
pencil, felt tip,
marker
Size: varies ½ to full page
Time: 10-20 minutes

3. Line, Tone/Shadow, and Texture/Material

This exercise is usually the final step after completing the previous two exercises. Having studied the still life for light and texture/material (pattern) separately, you should now put them together selectively with line effects to produce the strongest drawing. As you will learn later in the book, this is the basic concept behind the overlay *method.*

Once again the time spent is relative to the scope and complexity of the still life.

LIGHT

3

What is light?

Light *is the element of design that defines all that we see and how we see it. Sunlight and artificial light from any manmade source are the primary choices we have to determine how our drawings read and make a visual impact. We distinguish shapes or forms in space through* tone, value, *or* shade *(basically interchangeable terms) and shadows cast by light striking form.*

TONE, VALUE, OR SHADE

The terms tone, value, *and* shade *refer to the way light affects a shape, object, or form.* **Value** *is most often used to grade lightness or darkness. Values range from zero (0), which equals white, to 10, which equals black (Figure 3.1).*

 A value of 10 is usually reserved for shadow based on the rule of thumb "Shadow is darker than shade." This is an important factor because we can clearly read only form relationships with a lighter value next to a darker one. A value of 10 on a form with shadow value of 10 would blend together and the clarity of the form would be lost.

 Changes in value are produced by altering the direction and intensity of the light source.

31

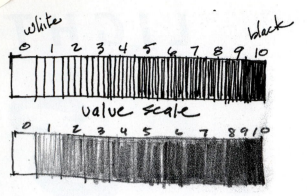
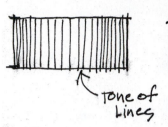
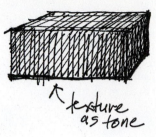

white 0 1 2 3 4 5 6 7 8 9 10 *black*

value scale

0 1 2 3 4 5 6 7 8 9 10

tone of lines

texture as tone

Figure 3.1
VALUE SCALE

SHADOW

There are an almost unlimited number of formulas for casting shadows. The key to understanding the use of shadow in a drawing is to follow the rule, "What you see is what you get." It is no more complicated than that. Reality-based shadows can be created using a simple lamp as a source on objects or models to simulate the scene you want to create.

*Shadows often have an **umbra**, a darker aura, and **penumbra**, a lighter aura (Figure 3.2). Shadows may appear crisp with hard edges or soft and blend more into the drawing. Your drawings should always maintain a clear and consistent light source.*

People who view your drawings may not be artistic, but they are used to seeing the effects of light in their daily lives. So, if you want them to accept the illusion of what you have drawn, your use of light will be critical.

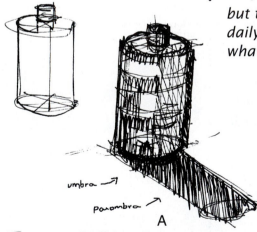

umbra
penumbra
A

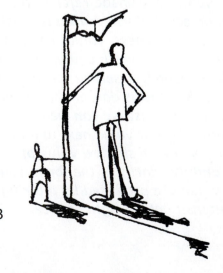

B

Figure 3.2

**A. SKETCH DONE WITH BLACK UNIBALL MICRO PEN
B. SHADOW RELIES ON SUN DIRECTION AND SCALE**

ONE-POINT SHADOW CASTING

1. Select a light source.

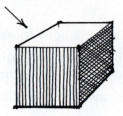

2. Apply tone to the form.

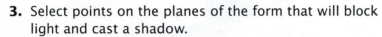

3. Select points on the planes of the form that will block light and cast a shadow.

4. Draw consistent angles from these points (typically 30°).

5. From the top shadow-casting points, use 45° angle lines to determine the length of the shadow. In reality, the shadow changes as the angle of the light source changes. When a light source is directly over an object, it produces no shadow.

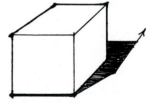

6. The 45° lines will intersect the 30° lines, then close out the shadow with a parallel line and a line to the vanishing point (VP).

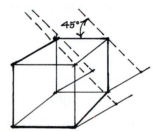

7. The same principles apply to this open-leg table.

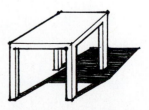

TWO-POINT SHADOW CASTING

1. Select a light source.

2. Draw lines through the shadow-casting points in the direction the shadow will fall.

3. Draw a line parallel to the object at point A.

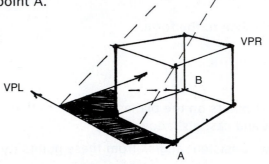

4. Where this line intersects a shadow-casting line from the light source, draw a line toward vanishing point left (VPL).

5. Where this line intersects the other shadow-casting line from the light source, draw a line toward vanishing point right (VPR).

6. Close the shadow with a parallel line back to point B.

Figure 3.4 shows a shadow cast through a window at a 45° angle.

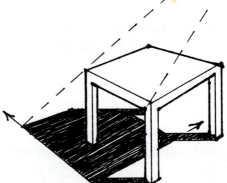

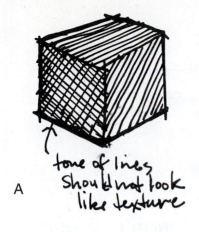

A

tone of lines
should not look
like texture

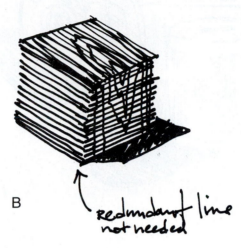

B

redundant line
not needed

Figure 3.3
TEXTURE OVER TONE

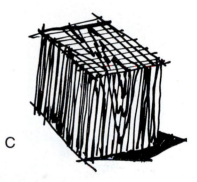

C

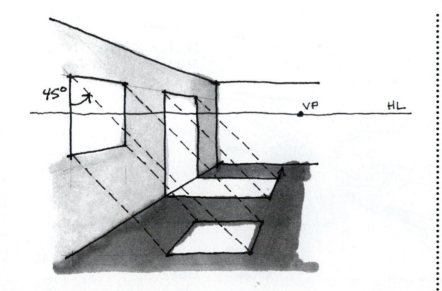

45°

VP HL

Figure 3.4

**SHADOW CAST THROUGH A
WINDOW, 45° ANGLE**

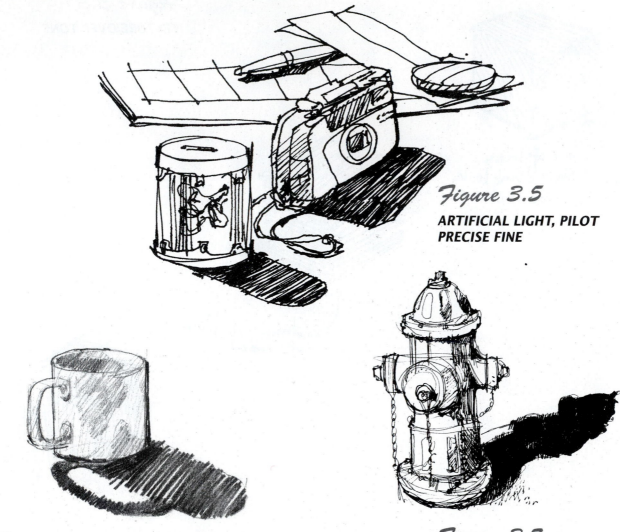

Figure 3.5

**ARTIFICIAL LIGHT, PILOT
PRECISE FINE**

Figure 3.6

**SKETCH DONE WITH A
#3B PENCIL**

Figure 3.7

**SKETCH WITH NATURAL
SUNLIGHT**

Figure 3.8

**BOLD SHADOW, NATURAL
LIGHT**

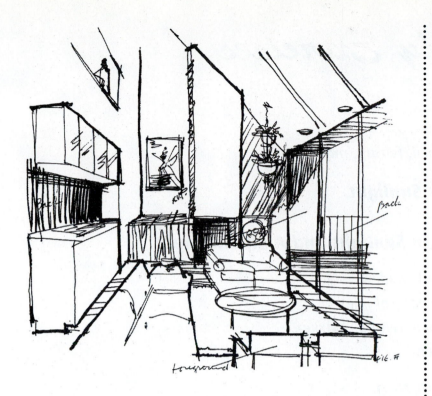

Figure 3.9
LINE WEIGHT STUDY

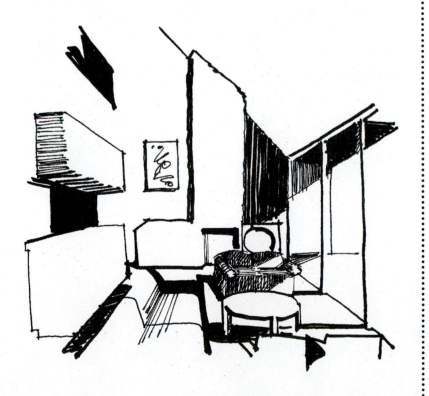

Figure 3.10
**INTERIOR LIGHT WITH
CONTRAST STUDY**

Light Study Exercises

1. Value Study

 a. Practice a value study 0–10

 b. Media: sketchbook, pencil, felt-tip, marker

2. Objects in Nature in Sunlight

3. Objects in Interiors in Sunlight and Artificial Light

 a. Concentrate on tone and shadow only

 b. Use shade technique or tone of lines

 c. Media: sketchbook, pencil, felt-tip, marker

 d. Time: 5–20 minutes each

4. Basic Forms (Cube, Cylinder, etc.)

 a. Choose typical light source, vary direction from upper left to upper right

 b. Work on tone first

 c. Shadow

 d. Practice umbra and penumbra

 e. Media: sketchbook, pencil, felt-tip, marker

TEXTURE

What is texture?

Texture *is the element of design that helps define the character of a space. Everything has texture ranging from rough to smooth. The type and extent of texture used also affect the principle of design: emphasis. Seize the opportunity to express texture since it produces the most interesting, active, sensual, tactile character in the drawing.*

MATERIALS

Both natural and manmade materials are affected by textures and patterns. In exterior sketches we find plant life, water, stone, and a variety of other natural materials. If there are architectural features in the drawing, both natural and manmade materials will come into play. When sketching interior spaces we find wood, stone, brick, glass, wall covering, floor covering, and fabric as popular materials (Figure 4.1A, B, C).

Obviously, certain materials are much easier to draw than others. It pays to emphasize those, while merely suggesting others. One of the keys to drawing materials is to carefully study and understand them. For example, there are certain distinct grain patterns in trees that are grown and harvested for furniture. The patterns vary in

Figure 4.1A

TEXTURE STUDY, BOLD CONTRAST

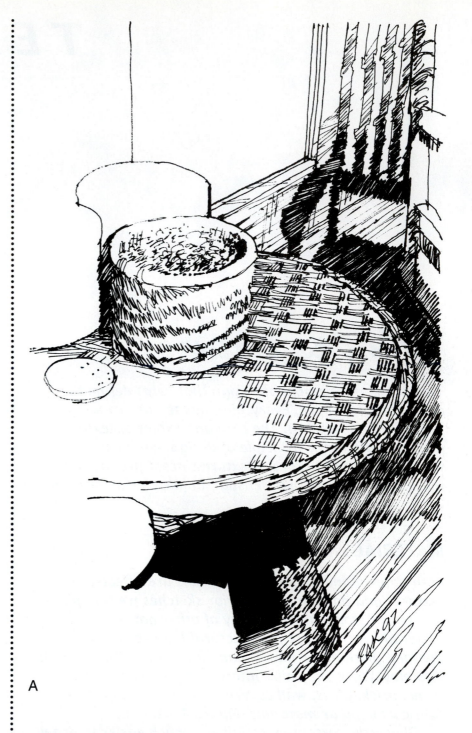

A

the way the tree is cut and whether hardwood or veneer is used. As mentioned previously, the average person may not be artistic but he or she has a sense of reality. If your drawings do not reflect this quality, the viewer will not accept your illusion.

bone
sketch

B

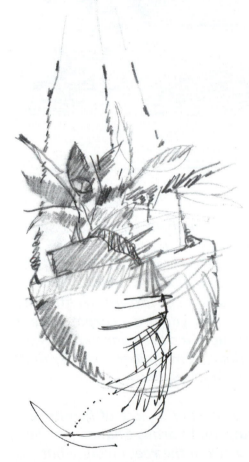

C Preliminary Sketch

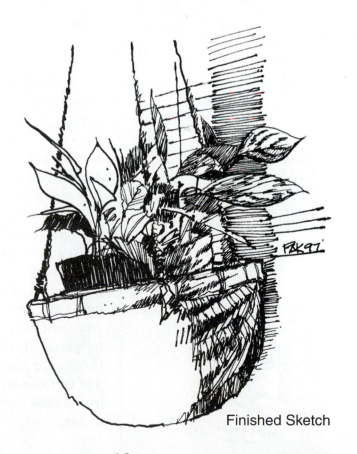

Finished Sketch

Figure 4.2
WOOD GRAIN AND BRICK STUDY

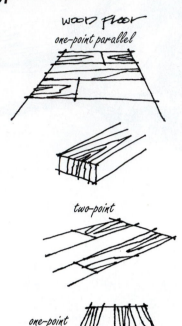

wood floor
one-point parallel

two-point

one-point vanishing

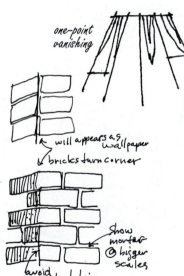

will appears as wallpaper

bricks turn corner

show mortar @ bigger scales

avoid redundant line

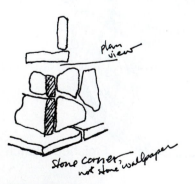

plan view

stone corner, not stone wallpaper

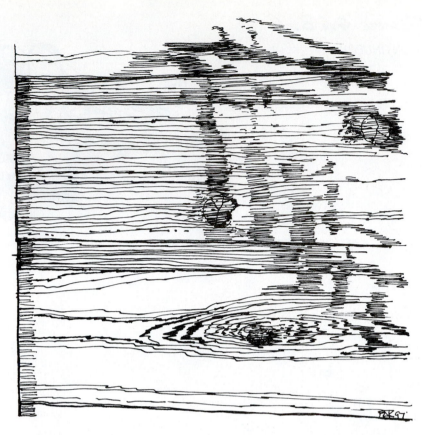

The way stone, brick, and wood flooring are laid also creates identifiable characteristics (Figure 4.2). These characteristics may be especially apparent in materials of standard sizes. The most popular flooring material is carpet, which is an excellent source of textural treatment. Again, you must take care in how you draw carpet since it is a milled product that produces a clear nonrandom linear quality. To keep the floor from appearing to fly up, both pattern and carpet pile must diminish in size in a perspective sketch.

Whether it is a window or part of a piece of furniture, glass is often a difficult material to draw. Changes in the value or clarity of what you see in the room from what you see outside helps the viewer believe the material must be glass. This is also true of drawing what you see through a glass tabletop (Figure 4.3). It is important to use techniques triggering cues and symbols that make it impossible for viewers not to believe what you want them to see.

Figure 4.3
TEXTURE STUDY WITH GLASS

Wall coverings and fabrics are materials that can be used to enhance a drawing. Often it is the pattern that brings the material to life. Drawing at a small scale, it is impossible to clearly see all of the detail of a pattern. Simply suggesting the pattern with a convincing use of texture and line will be effective. Basic materials, such as nylon and leather, can be more easily suggested by clearly defining the way the material is used on the furniture—the tufting, the seams, and the skirt, for instance.

Textures and materials may be drawn generically or realistically. There are several types of generic textures: **stippling** (the use of graded dots, Figure 4.4), cross-hatching, loops, and so on. It is important not to use the same generic texture for different materials in the same drawing. If you use stippling for hard-surface materials such as plaster or concrete, you must not use it for a soft fabric. This would only confuse the viewer, who is adjusting his or her eye to the use of your generic texture.

*Although realistically capturing the illusion of a
specific material on paper often depends on your drawing
skills, you must have a working knowledge of its growth
patterns, structural characteristics, construction, and
basic features or details. With patience and practice, the
proper emphasis on textures, materials, and patterns in
your drawings will prove to be a source of satisfaction
and pleasure while enriching the visual effect through a
strong tactile experience.*

Texture Exercises

I. TEXTURE EXERCISE: REAL AND GENERIC

The first exercise in texture/materials is a simple controlled "learn to see" study. Look at specific textures or materials and draw them in a square or rectangle. Or just have fun playing with texture.

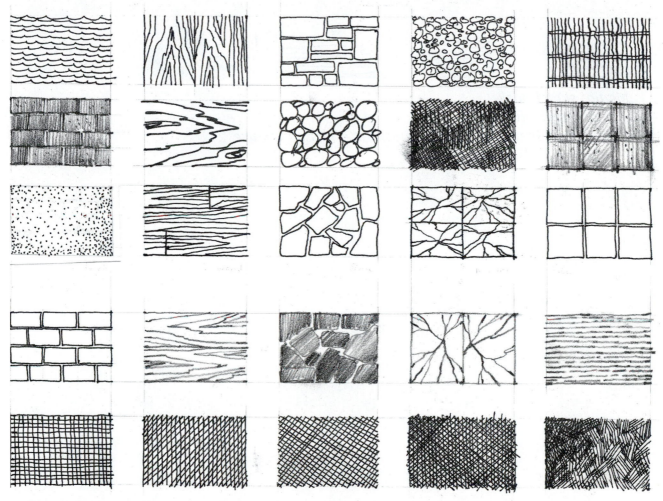

Media: sketchbook
 pencil, felt-tip
Size: 1" x 1½ "

II. TEXTURE SHOWING RECEDING EFFECT

1. Media: sketchbook
 pencil, felt-tip
2. Draw in perspective to show vanishing effect on texture

Part Two

DESIGN DRAWING

What is design drawing?

Design drawing is a visual language or shorthand used in the schematic or preliminary phase of the design process to help in the search for potential solutions to design problems.

In this section we will examine bubble flows, conceptual doodle/diagrams, perspectives, and image perspectives that are used for design drawing. These types of drawings are meant to be used in house *by the designer while problem solving and are generally not shown to the client. This type of drawing has its own look, style, and integrity, and it should not be judged on rendering skill or artistic merit. In fact, it is the speed with which this style of drawing can be put on paper, not the accuracy, that counts.*

In certain high-stress situations, these quick drawing skills can be essential. At the student level, whether working on short-term sketch problems or eight-hour sketch problems, these skills may be a deciding factor in examinations for professional licensing.

In certain situations, however, design drawing can be used to create a quick sketch to effectively express an idea to a client. One typical example popularized over the years is referred to as **napkin art***, so-called because a designer sketches an idea on a napkin during a business lunch. This skill impresses most clients and often reinforces the historic phrase, "A picture is worth a thousand words." Most graphic educators consider design drawing to be the most valuable and lasting tool that students carry with them into the design profession.*

Figure P2.1

PLAN VIEW, ELEVATION, AND PERSPECTIVE

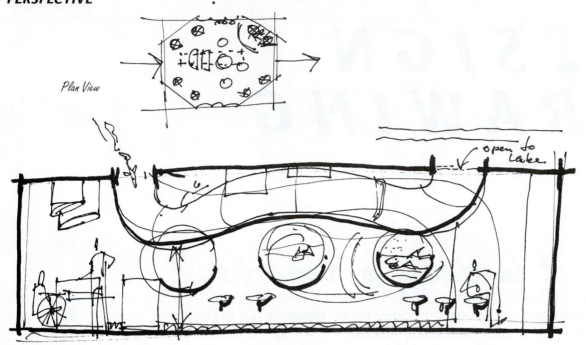

Plan View

open to Lake

Elevation

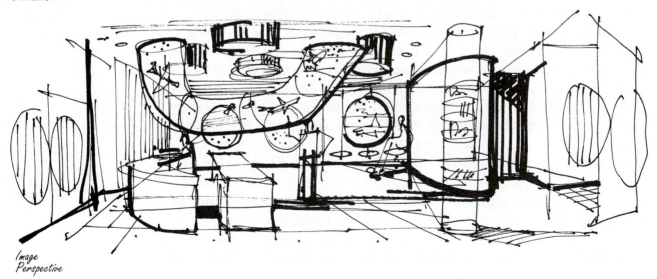

Image
Perspective

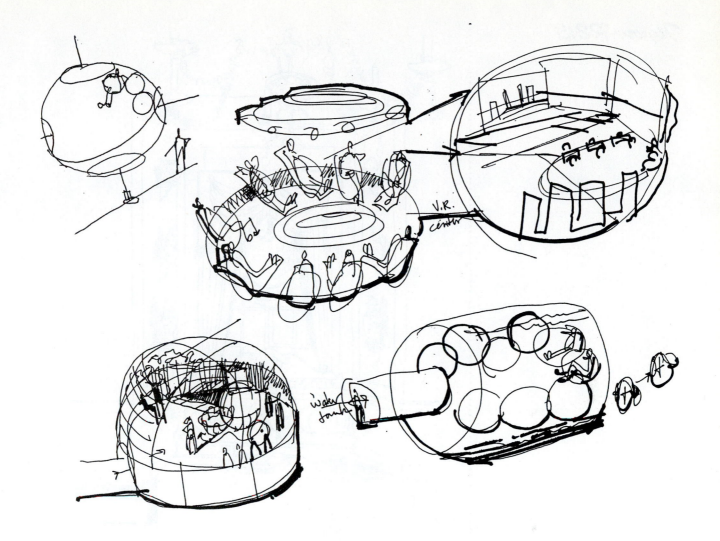

Figure P2.2

THINK TANK STUDY

CONCEPTUAL DOODLE/DIAGRAMS

What is a conceptual doodle/diagram?

The conceptual doodle/diagram is the heart of the schematic phase of design. It is the designer's first marks on paper after research and programming have taken place. Conceptual doodles are the designer's visual shorthand using drawings that are sketchlike, small, and fast. These diagrams allow the designer to examine many different ideas at this preliminary stage of the design process. Conceptual doodle/diagrams are in-house aids to the designer and, as a general rule, they are not shown to the client. This means they need to be understood only by the designer and are not necessarily a communication tool.

Everyone has doodled at one time or another and it can be a satisfying, if mindless, activity. In our definition, we have added the word *conceptual* in front of *doodle* to remind us that this activity is definitely *not* meant to be mindless. Figures 5.1A and B are not conceptual doodle/diagrams. The pen is simply a sketch of a pen. The lightbulb can be symbolic of a "bright idea," but as you will see, neither of them is a conceptual doodle/diagram.

Figure 5.1

EXAMPLES OF WHAT IS NOT A CONCEPTUAL DOODLE/DIAGRAM

Conceptual doodle *is defined as a form of design graphics expressing a word, space, or action, to be used to examine potential design solutions in the schematic phase of the design process. The key word is* potential, *since at this time you should look at alternatives that may be further developed (Figures 5.2 and 5.3).*

Figure 5.2

CONCEPTUAL DOODLE/ DIAGRAM PROBLEM: DAYCARE CHIILDREN'S SEATING CHART WITH BASIC SHAPE/FORM, SCALE

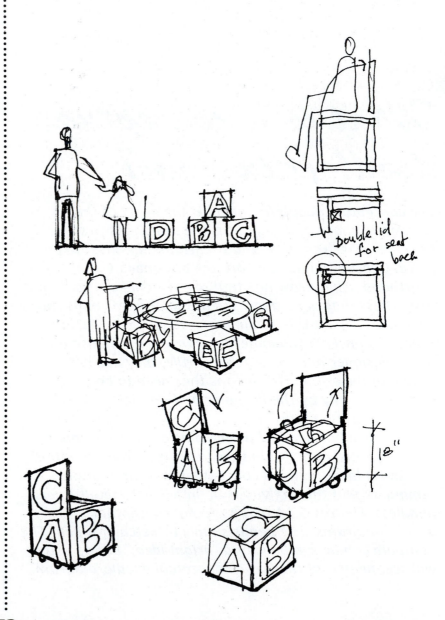

Figure 5.3

DIAGRAMS OF A PLAY SPACE FOR CHILDREN WITH DISABILITIES

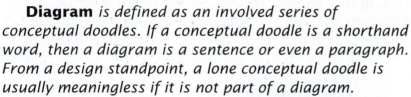

Diagram *is defined as an involved series of conceptual doodles. If a conceptual doodle is a shorthand word, then a diagram is a sentence or even a paragraph. From a design standpoint, a lone conceptual doodle is usually meaningless if it is not part of a diagram.*

Conceptual doodle/diagrams become the personal shorthand of designers. They may be realistic, symbolic, *or* abstract.

The vast majority of conceptual doodle/diagrams are symbolic, since realistic drawings tend to be more time-consuming. If they are repeated often enough, abstract drawings that have meaning for us eventually become symbolic. For example, if there was one place left on earth where Coca-Cola was not sold, its symbol would be abstract to those people. However, if by some form of magic a Coke machine were installed, the abstract letters would, in a very short time, become symbolic of the soft drink they represent.

The basic design process starts with data collection and programming, identifying client needs, and clarifying their image and character. You begin the preliminary design process with conceptual doodle diagrams using the elements *and* principles *of design. The following are typical* elements: *form, scale, color, texture, and light. The* principles *are: unity, variety, harmony, balance, emphasis, repetition, and proportion. The design process includes:*

- *project program*
- *research*
- *preliminary design*
 - *a. bubble flow*
 - *b. conceptual doodle/diagrams*
 - *c. image perspectives*
- *final design*

CONCEPTUAL
DOODLE/DIAGRAMS

When working on preliminary designs, I recommend moving from the **macrocosm**, or overview, to the **microcosm**, or smallest detail (Figure 5.5). When first working with conceptual doodle/diagrams, beginning design students are tempted to jump to preconceived notions for design solutions rather than letting solutions develop through the natural course of design evolution. They often have the tendency to work backwards by coming up with a design decision and then doing conceptual doodle/diagrams to support the end result. This, of course, entirely defeats the purpose of the diagram. The use of conceptual doodle/diagrams is not only critical in the design development phase, but they will serve as proof of a logically conceived and functional preliminary design solution.

Reminder: At this point it is evident that sketch figures are very important in conceptual doodle/diagrams to help establish a sense of scale and proportion (Figure 5.4).

Figure 5.4

EXAMPLE OF SCALE FIGURE TYPES FOR USE IN DIAGRAMS

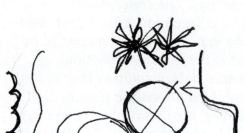

SITE

Figure 5.5

STUDY FROM MACROCOSM TO MICROCOSM: BEACH HOUSE EXAMPLE

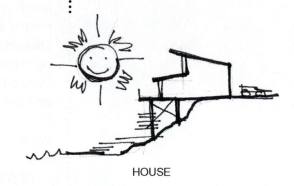

HOUSE

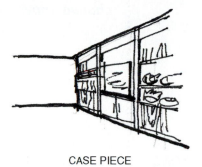

CASE PIECE

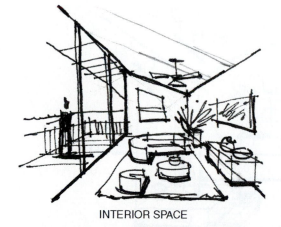

INTERIOR SPACE

DETAIL

55

CONCEPTUAL
DOODLE/DIAGRAMS

CONCEPTUAL DOODLE/DIAGRAM PERSPECTIVES

Conceptual doodle/diagrams may be plan, elevation, section, or perspective drawings. The conceptual doodle/diagram perspective is freehand, small, fast, and loose. It may or may not be in color. It is not meant to be pretty, but rather it should express action/reaction, showing a particular potential design solution that is best seen and understood in the third dimension (Figure 5.6). Unlike traditional perspectives, it can have notes, arrows, or other symbols drawn all over it to help the designer in the creative process. Remember, conceptual doodle/diagrams are part of the preliminary phase of design and are considered in-house drawings that are not used for client presentation. These perspective sketches are most effective when illustrating things in the design that change, move, or have some flexibility—action/reaction.

Figure 5.6

CONCEPTUAL DOODLE/DIAGRAM PERSPECTIVE ILLUSTRATING ACTION/REACTION

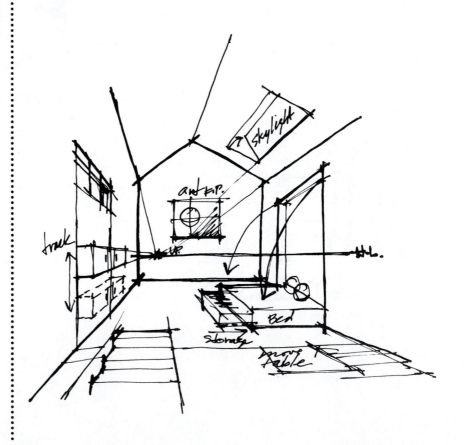

BUBBLE FLOW DIAGRAMS

Bubble flow diagrams are one of the most popular schematic phases of design studies. They are used for space planning and circulation. A five-step bubble flow version that stylistically falls under the umbrella of conceptual doodle/diagrams leads to a preliminary floor plan.

An unlimited number of bubble flow diagrams may be generated by client information in the facilities program statement. Of course, the number of diagrams the designer pursues will be controlled by contract deadlines—time limitations are always a factor. The bubble flow diagram with the best potential will be developed in the final design phase. As in all conceptual doodle/diagrams, the bubbles are a designer's shorthand; they are often accompanied by a specific and, in some cases, lengthy verbal description.

All of the spaces listed in the client's design program should be represented by an individual bubble. It is advisable to place the name of the space or room in the bubble. The bubbles should be drawn freehand since the use of a circle template is too formal and time consuming. Color can be used to give a psychological sense of space. Warm colors are active; cool colors are passive.

Following are guidelines for using bubbles as a language:

1. The size of the bubble relates directly to the size of the space it defines. This is based simply on proportion: a small bubble may represent a 50-square-foot space, while a bubble 4 times its size represents a 200-square-foot area.

2. Two bubbles physically touching indicate that two spaces are adjacent to one another. But this step does not clarify what is between the spaces—which may be a wall, partition, or some other form of space divider.

57

3. *Overlapping bubbles indicate spaces that interact, share function, or are linked in concept through open-space planning.*

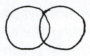

4. *An opening between the bubbles indicates that the spaces do not touch and may be separated by a corridor.*

EXAMPLE OF A FIVE-STEP BUBBLE FLOW DIAGRAM

Step 1. This step indicates the *WHERE* or location of each space as communicated to the designer and defined by the client's needs.

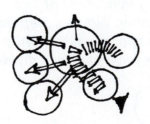

Name the spaces: Living room, etc.

Step 2. This is a vital step in a circulation study. It indicates *HOW* the people are moved through the spaces. A key with strong graphic symbols should be used to indicate major or minor circulation patterns or any other form of movement including site lines or view. You will need a key for this step.

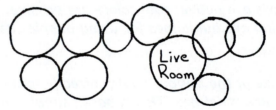

Step 3. This step converts the bubbles into basic geometric shapes that will become recognizable as a floor plan in Step 4.

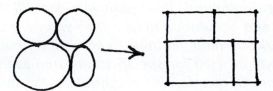

Step 4. This step shows a single-line floor plan with recognizable architectural features such as doors, windows, fireplaces, and so on. Spaces that are separated by walls or some other form of divider are now clear.

Step 5. The final step is a preliminary layout. It should be to scale or "eyeball" to scale. All wall thicknesses and architectural features are shown. Floor materials with appropriate textures should be shown. It is beneficial at this point in the schematic phase of design to place generic furniture in the plan. Commitment to specific pieces will be made at a later stage in the design process.

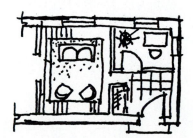

CONCEPTUAL
DOODLE/DIAGRAMS

At the completion of a five-step bubble flow, you will see a clear progression of thought and analysis. When placing the steps side by side, you see not only their logical relationships but often you are able to spot a problem that might have been missed or inadequately solved. The preliminary floor plan will meet all the client's functional and circulation needs. Now you are ready to start to make all modifications to achieve a final floor plan that will be used for specifications and eventual construction. Of course, this potential design solution is in the second dimension, or plan view, only. You must do conceptual doodle/diagrams in elevation, section, and perspective at the same time to truly develop your design in a logical sequence. As a quick sketch-style drawing tool, a five-step bubble flow can play an important role in helping to solve problems in the schematic phase of design development.

Conceptual Doodle/Diagram Exercises

I. FIVE-STEP BUBBLE FLOW DIAGRAM EXERCISE

Practice the five steps (use an existing class project)
- a. Media: sketchbook or parchment paper
 pencil, felt-tip, marker
- b. Freehand drawing (no circle template)

II. CONCEPTUAL DOODLE/DIAGRAM EXERCISE

Choose a problem to solve (use an existing class project) and state it clearly
- a. Work from macrocosm to microcosm
- b. Use the elements and principles of design
- c. Use sketch figures
- d. Media: sketchbook or parchment paper
 pencil, felt-tip marker
- e. Small, fast, freehand
- f. Time: 30 seconds to 10 minutes each

PERSPECTIVE DRAWING

6

What is a perspective drawing?

The perspective drawing is one of the oldest and most popular means of design communication. Clients tend to feel more comfortable with this pictorial view, which is often much easier to relate to than the floor plans, elevations, or sections commonly used by designers to express design solutions. Two key buzz words often related to perspective drawing are reality and believability. I teach students not to search for magic solutions or secret formulas but to accept and recognize the "what you see is what you get" concept. Simplistically speaking, we see a modification of one- and two-point perspective, depending on how we move our head and eyes to view a room or space.

The following terms are basic to the understanding of perspective drawing:

Station point: The point from which a person views a space or object.

Ground line: The place the visual plane meets the ground.

Horizon line: An imaginary line that is always consistent with the eye level.

Vanishing point: *A point or points that are always on the horizon line; the points where parallel lines converge.*

Picture plane: *A plane in space that frames and defines the perspective that is drawn.*

In more than 30 years as a professional renderer, I have found that a clear majority of interior perspectives are best shown in one-point perspective, while the best exterior views seem to be in two-point perspective. You should certainly learn the means to produce mechanical perspectives as part of your foundation study, but you should also learn freehand and eyeball methods as soon as possible. Almost all of my perspective drawings have been done by the eyeball method, with the exception of some complex cases in which I used mechanical methodology. Therefore, it seems practical to present only eyeball methods in this book.

There are a wide variety of perspective types and a great diversity of effective drawing styles. Rendering is clearly an art form and must be subject to personal style and taste. It is important to be exposed to many design drawing styles, even emulating those you admire, but over time your own style will emerge.

The following types of perspectives will be presented in this chapter:

- *Image perspectives*
- *Final perspectives*

These perspective drawing types and the amount of rendering in them relates strictly to the role they play in the design process. Time and budgetary factors will affect their use as well. This is especially true for drawings used in client presentations, which are often considered extras and are billed accordingly. If they are eliminated, a potential communication gap may develop that may prove costly at a later date.

IMAGE PERSPECTIVES

The image perspective is a tremendously effective in-house design tool, since all design projects deal with the clients' concept of their own image and character. Image perspectives should be done in eyeball sketch style; generally they are 8½ × 11 inches or smaller in size. These drawings are part of the schematic or preliminary phase of design, so they allow the designer to examine many potential solutions as quickly as possible. Image perspectives relate directly to the use of the elements and principles of design. So the use of line, tone, texture, or color will depend on what the designer is trying to study about the space.

Image perspectives thus become a great source of information concerning form and scale relationships, light sources, texture and material alternatives, and much more. Neatness and accuracy are not major characteristics of an image perspective; time spent on these drawings should be kept to a minimum— approximately 10 minutes to no more than an hour. In some cases an image perspective can be used to illustrate a concept or present a theme to a client before the actual design process begins. In fact, there are many acceptable styles for image perspectives, from very loose and sketchy to more refined; some styles even use drafted lines if they don't make the drawing appear too stiff and tight. These perspectives may be used for promotion or preliminary client presentation, and several hours may be devoted to their completion. Figures 6.1 through 6.11 are examples of image perspectives.

PERSPECTIVE
DRAWING

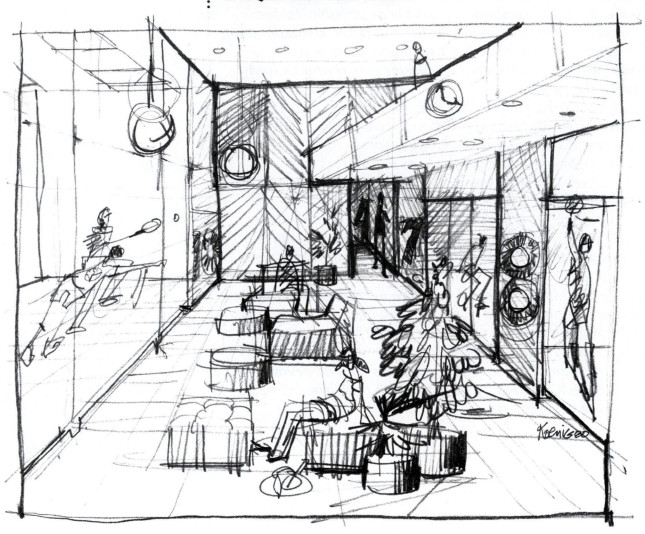

Figure 6.1B

IMAGE PERSPECTIVE: PENCIL, 8 x 10, 10 MINUTES, RACQUETBALL CLUB DESIGN

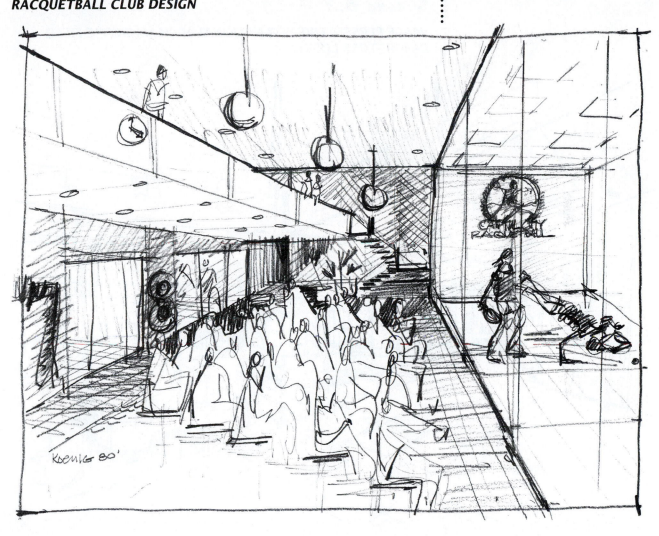

Figure 6.2

IMAGE PERSPECTIVE FOR NATIONAL HIGH MAGNETIC FIELD LABORATORY LOBBY

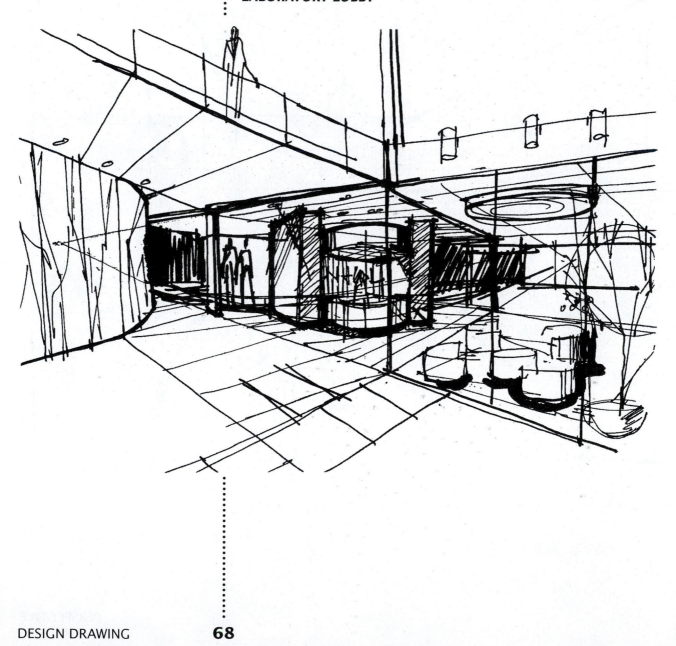

Figure 6.3

IMAGE PERSPECTIVE: STILL LOOSE AND FAST BUT USES SOME MECHANICAL LINES—MY DAUGHTER MOYA'S PROPOSED BEDROOM

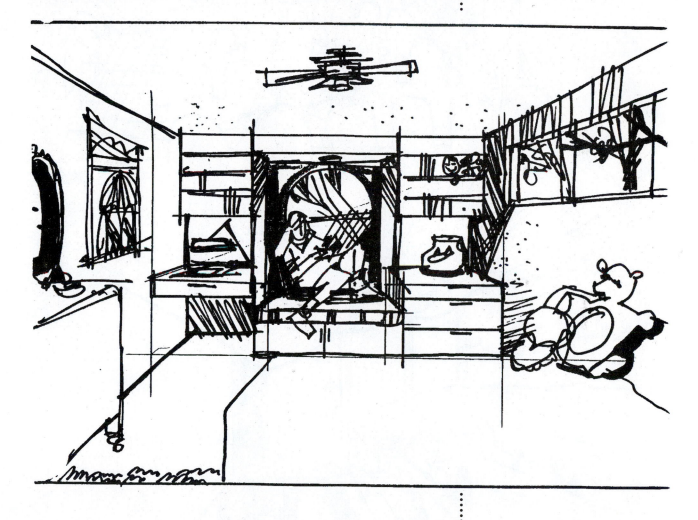

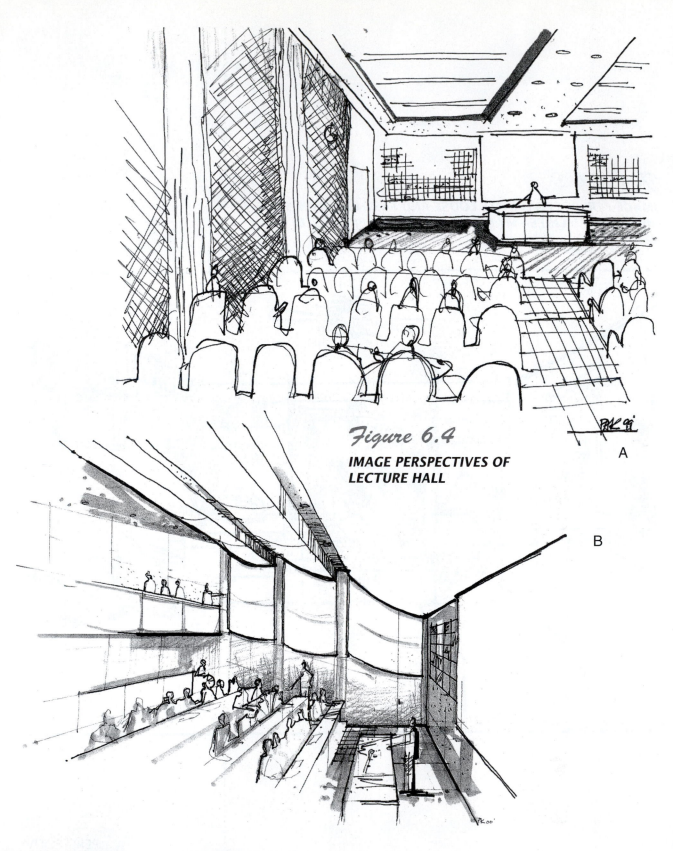

Figure 6.4
IMAGE PERSPECTIVES OF LECTURE HALL

A

B

DESIGN DRAWING **70**

Figure 6.5
IMAGE PERSPECTIVE: TWO-POINT, BASIC OFFICE DESIGN

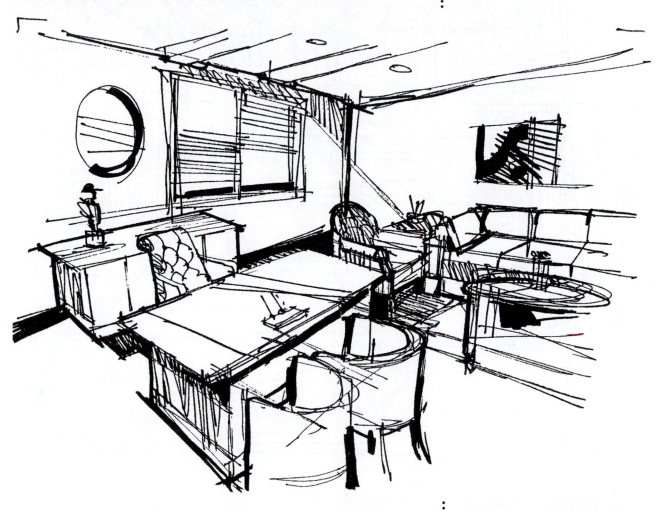

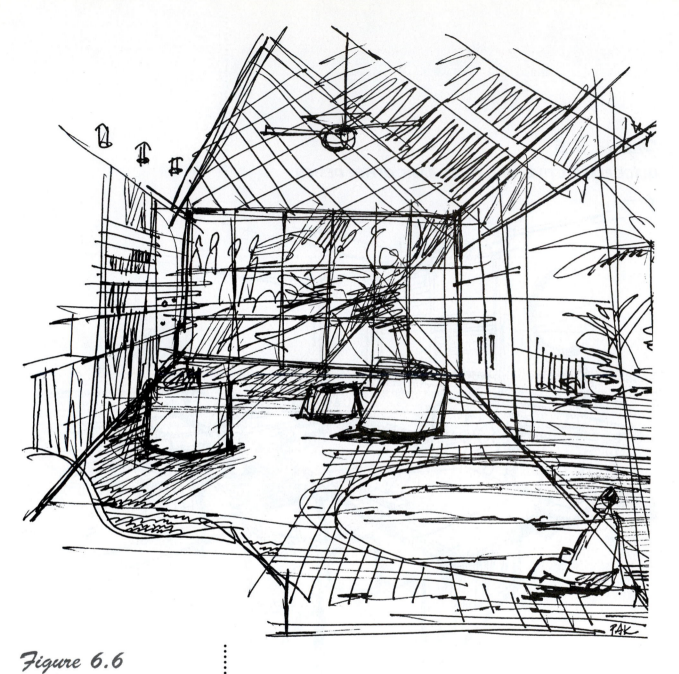

Figure 6.6

IMAGE PERSPECTIVE: FAMILY ROOM/POOL AREA

Figure 6.7
IMAGE PERSPECTIVE: HOUSE DESIGN

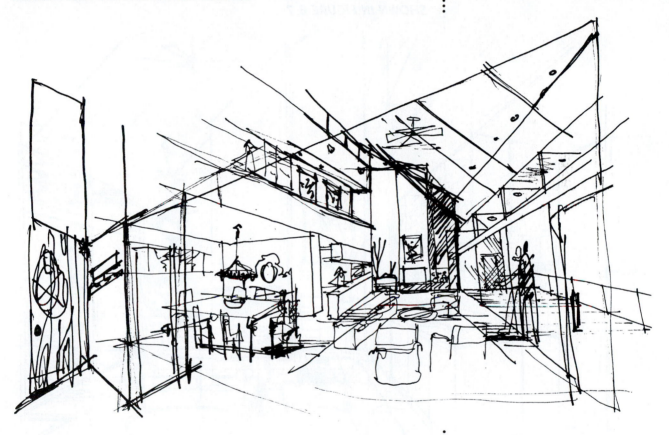

PERSPECTIVE
DRAWING

Figure 6.8
IMAGE PERSPECTIVE REFINED FROM THE ONE SHOWN IN FIGURE 6.7

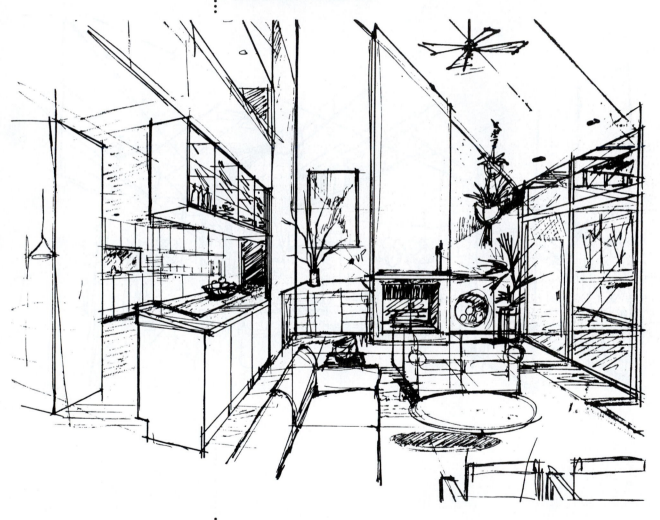

Figure 6.9
IMAGE PERSPECTIVE, REFINED: HOUSE DESIGN

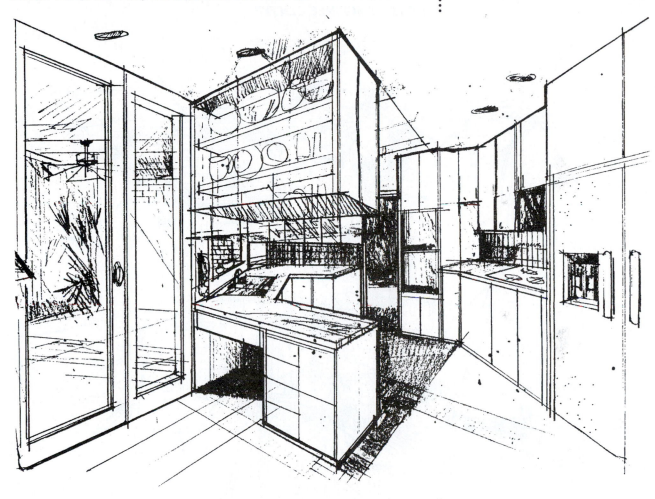

PERSPECTIVE
DRAWING

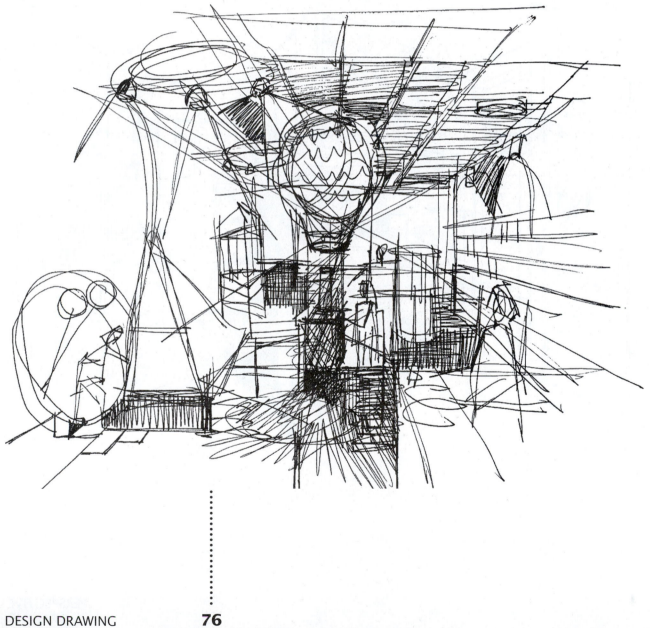

Figure 6.10
**IMAGE PERSPECTIVE SKETCH: PROPOSED
ODYSSEY SCIENCE CENTER**

Figure 6.11

IMAGE PERSPECTIVE WITH A MORE FINISHED RESULT

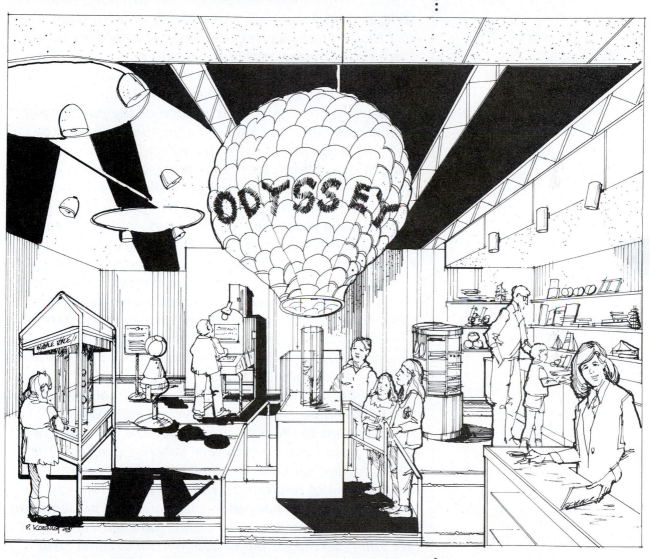

P. KOENIG 93

PERSPECTIVE
DRAWING

FINAL PERSPECTIVES

As shown in this book, a final perspective is the end result of the overlay method *(see Chapter 9).*

The visual appearance of a final perspective can vary greatly from project to project. Final perspective drawings may be black and white, partial color, or full color. They can be loose and sketchy or polished and photo-realistic.

Final perspectives are usually budgeted as an extra expense. When budgeting perspective drawing, time, size, style, and media must be considered. Unfortunately, the cost factor often negates the use of perspectives because these three-dimensional representations of design solutions can be so accurate that they are an invaluable tool in assuring clients that they are getting what they really want long before construction or the purchase of furniture begins. Conversely, if something needs to be changed it will be far more cost effective at this time, making the up-front cost of perspective drawings well worthwhile. Figures 6.10 and 6.11 show two versions of an image perspective for a science center.

For many years, final perspectives in black and white often relied on tight pen and ink drawings using more rigid mechanical methods. Today computers are playing an even greater role in perspective drawing, although they are still being used most often to wire frame *the drawing, which is then completed with hand rendering. The role of computers will continue to change as the rendering software becomes less expensive and more user friendly; their potential is limitless.*

As a professional renderer, all of my final drawings are based on variations of the eyeball method with modifications to the overlay method. The drawings vary in style from quite loose to very polished in effect. The current trend is to take a simpler and freer approach in the teaching of rendering for design presentations.

Not much has changed in client-oriented presentations in the last 20 years. In most cases, full color renderings are still reserved for major commercial architectural projects. It is my hope, however, that designers will not lose the ability to draw and communicate at the presentation level and that books like this will remain part of design drawing education.

Image Perspective Exercises

CREATE FOUR DRAWINGS ON AN 18 x 24 BOARD

a. Two drawings in one-point perspective and 2 drawings in two-point perspective

b. Two drawings in pencil or felt-tip and 2 drawings in felt-tip and marker

c. Parchment or sketchbook paper (these are preliminary drawings)

d. Freehand eyeball method

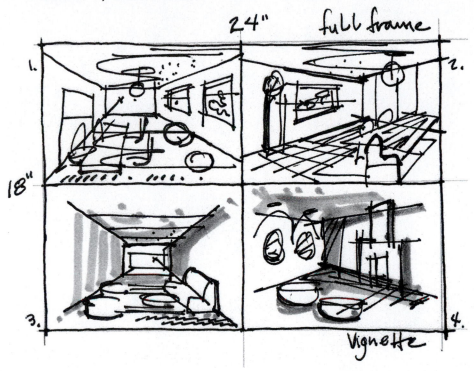

Part Three

..

DRAWING
PROCESS

What is the drawing process?

The **drawing process** for designers is critically linked to the **design process** for both problem solving and the presentation of the solution.

In Chapter 5 we covered conceptual doodle/diagrams and image drawing and their role in the design process at the schematic or preliminary phase. Next we move into the design development or final phase of design, where a variety of drawing choices are available to communicate the solution to the client. This level of drawing requires certain refinements that will take a proportionately longer span of time. At this point in the process, floor plans, lighting, elevations, furniture, and furnishing specifications have been finalized.

Choices for drawing presentation type are still tied to time and budget. The perspective drawing is the most effective choice since it is pictorial and easily understood by the client. Figures P3.1 through P3.4 were done while talking to a client in a meeting. At the presentation level, the designer may choose not to do his or her own perspective drawings, commissoning a professional renderer instead. This decision often depends on how valuable the designer's time may be doing other things and, of course, the cost may be charged back to the client. Although, comprehensive perspective

Figure P3.1
STUDY DONE WITH CLIENT: FLORIDA STATE UNIVERSITY DISTANCE LEARNING CONFERENCE ROOM

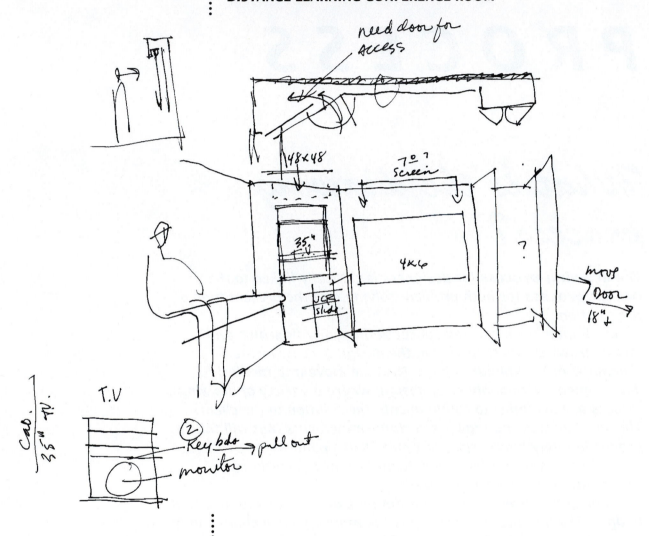

Figure P3.2

**STUDY DONE WITH CLIENT: FLORIDA STATE UNIVERSITY
DISTANCE LEARNING CONFERENCE ROOM**

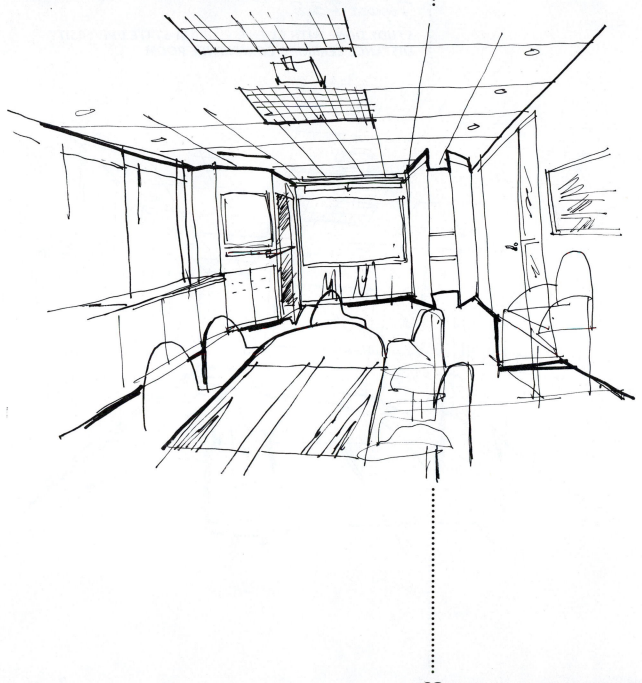

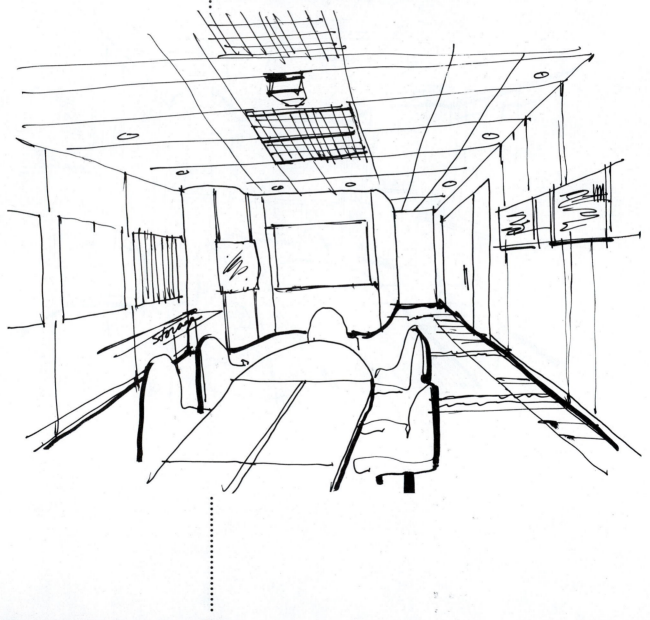

Figure P3.3

STUDY DONE WITH CLIENT: FLORIDA STATE UNIVERSITY DISTANCE LEARNING CONFERENCE ROOM

Figure P3.4

**STUDY DONE WITH CLIENT: FLORIDA STATE UNIVERSITY
DISTANCE LEARNING COFERENCE ROOM**

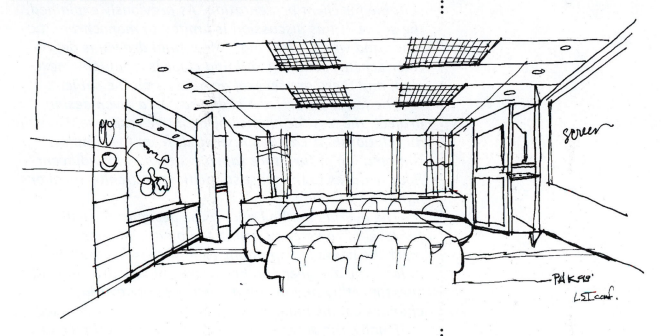

screen

drawings may not prove to be cost effective in most residential situations, they are well worth the expense in commerical projects because they allow clients to see exactly what they are getting before construction begins, thus preventing changes that can be far more costly than the money invested in presentation drawings (Figures P3.5 through P3.7). Using logic in the drawing process— thinking through what to show the client and what drawing techniques to use—is essential at this stage.

This section discusses the overlay method, beginning with composition studies and culminating in drawings suitable for client presentation. As previously explained, the scope of this discussion is limited to monochromatic— black and white—drawings. Most final drawings define color scheme solutions. Adding color is a valuable next step, and there are several good texts on the subject.

The fewer surprises a client has on a given design project, the less the chance of negative response. Literally all relationships can be illustrated, from the simplest combination of furniture fabric patterns with adjacent floor textures to the most sophisticated architectural or lighting situations.

The overlay method allows the designer to customize the level of complexity and detail on a job-by-job basis to meet the needs of communication with individual clients. In fact, the designer can bring preliminary drawings to a client meeting and, using a tracing paper overlay, changes can be made while ideas are being exchanged.

Finally, the drawing process allows the designer to express ideas at all phases of the design process. The client participates in the evolution of the solution, making meaningful changes along the way and giving final approval at the appropriate point of completion. These drawing and presentation skills give the designer great confidence in achieving client satisfaction long before construction begins.

Figure P3.5

STUDIES DONE WITH CLIENT: FSU ACADEMIC COMPUTER NETWORK SERVICES; PLAN AND PERSPECTIVES, LOUNGE AREA

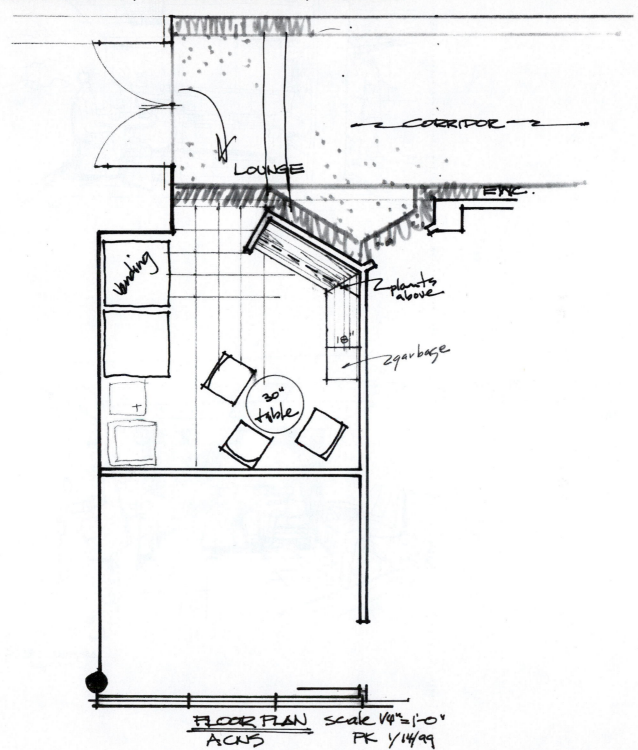

CORRIDOR

LOUNGE

E.W.C.

vending

plants above

18"

garbage

30" table

FLOOR PLAN
ACNS

scale 1/4"=1'-0"
PK 1/14/99

Figure P3.6

PERSPECTIVE VIEW OF FIGURE P3.5

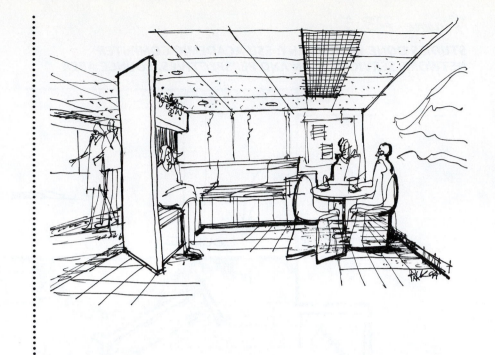

Figure P3.7

CUT A REAL PICTURE FROM MAGAZINE TO USE AS A MURAL

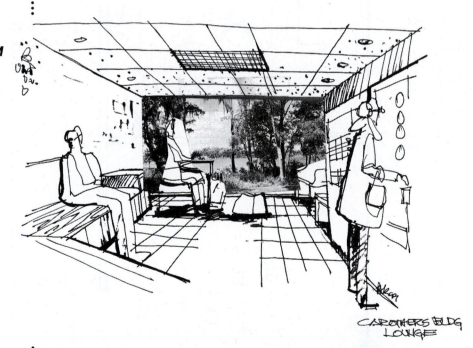

ONE-POINT EYEBALL PERSPECTIVE

7

What is one-point eyeball perspective?

I differentiate the term **eyeball perspective** from the term **mechanical perspective** based on the method and style used. In fact, the use of mechanical tools—T-square, triangle, and so on—has nothing to do with the term eyeball; the drawings may be entirely freehand or may be created partially with mechanical tools. This chapter demonstrates two distinct approaches to eyeball perspective drawing.

The eyeball method is extremely valuable for quick sketch-type communication. Napkin art, or a sketch done on a napkin during a lunch meeting, is this type of drawing. This type of sketch allows the designer to express ideas in perspective at a moment's notice without a drafting table and tools. Eyeball methods can be used for image perspectives for in-house design or as an effective alternative to mechanical methods for final client-level perspectives. With the **one-point quick eyeball method**, the only critical variable is depth perception since this is always an educated guess. However, with the eyeball method this guesswork is eliminated by the use of a vanishing point depth (VPD). Certainly no eyeball method is foolproof and, based on

buzzwords such as reality *and* believability, *changes that allow the drawing to better communicate always take precedence over grids and mechanical rules. The term **fudge factor** was developed by artists and renderers to give them license to adjust things in a drawing to make them appear more believable.*

*One-point perspective works best for interiors since it allows the designer to show three walls of a space and concentrate on the focal point, or area of emphasis. There are two choices for overall page composition: **full frame** (Figure 7.1), where the drawing extends to the picture plane, and **vignette** (Figure 7.2), where the four planes fade out equally on the paper.*

Figure 7.1
COMPOSITION: FULL FRAME

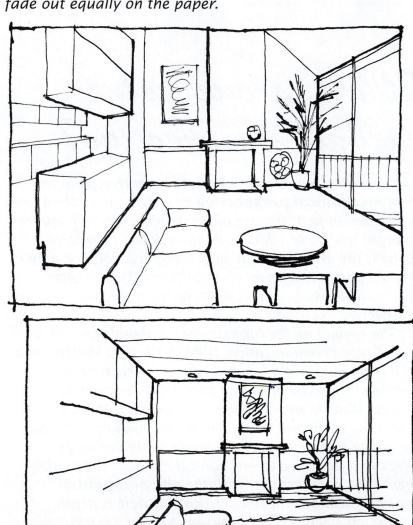

Figure 7.2
COMPOSITION: VIGNETTE

ONE-POINT QUICK EYEBALL METHOD

No scale is used. The height or length of a line is merely what you say it is. Proportion is definitely the key to believability. However, all of the basic rules of perspective drawing should be used:

1. Draw true height line

Pick the rear elevation of the perspective view. Include, at the left, a true height line (THL), which is the height of the space and to which the heights of everything in the drawing must be held.

2. Draw base of rear elevation

Represents true widths in the space; must be in proportion to THL.

3. Draw rear elevation

4. Select the horizon line; approximately 3′6″ or 5′6″ is still appropriate.

5. Place the vanishing point (VP).

ONE-POINT
EYEBALL
PERSPECTIVE

6. Select the sense of depth in the drawing. (This is a critical step since this is an educated guess and your practice with proportion is vital here.)

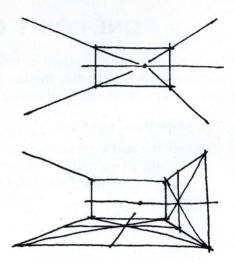

7. Use the x geometric method to divide and expand space. The x geometric method is based on the fact that drawing an x through a perfect square finds the center point. This principle carries over into perspective drawing with a square but vanishing plane. This method is extremely accurate if your initial guess is a good one. (Remember: Heights and widths will always be accurate because you establish them as a given, but if your depth is off, forms or furniture will clearly appear to be too foreshortened or extended) (Figure 7.3).

Figure 7.3

COMMON OBJECT: DESK, 30" H x 72" W x 36" D

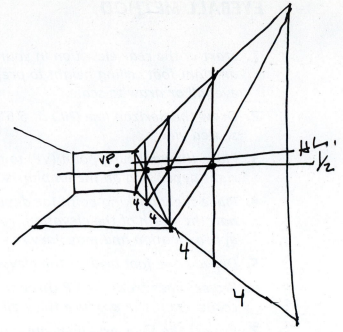

EXPAND WALL X METHOD

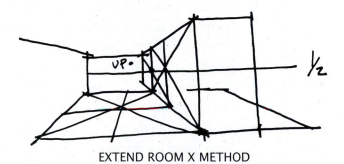

EXTEND ROOM X METHOD

EYEBALL METHOD

1. *Start at the rear elevation in your view of choice. Use an eight-foot ceiling height to prepare your grid. Use eyeball or draw to scale.*

2. *Draw the horizon line (HL) at 5'6" (or at 3'6" for a seated view).*

3. *Place the vanishing point (VP) to the left of center (or right depending on the emphasis of the view).*

4. *Place the vanishing point for depth (VPD) one and a half the width of the elevation from the VP. (This is an approximation and may vary.)*

5. *Draw a one-foot grid on the elevation.*

6. *Project lines from the VP through the rear elevation corner points to produce the wall planes.*

7. *Project the floor grid lines out from the VP.*

8. *Draw a diagonal line from VPD through point E to create point A.*

9. *Draw a parallel line from A to B, a perpendicular line from B to C, and a parallel line from C to D to complete the picture plane.*

10. *Draw horizontal lines at the points where the diagonal line EA intersects the floor vanishing lines; this produces a floor grid.*

11. *Now, using the VP from the elevation through the floor grid, draw the remaining wall and ceiling grids (Figure 7.4).*

Note: *The placement of the VPD is the critical factor that determines the proportion and/or distortion of the entire grid. It may be adjusted as needed. Also I suggest using a color such as red for guide lines—horizon line and VPD, E, A—since at completion of the method they may be removed, causing less confusion while using the grid.*

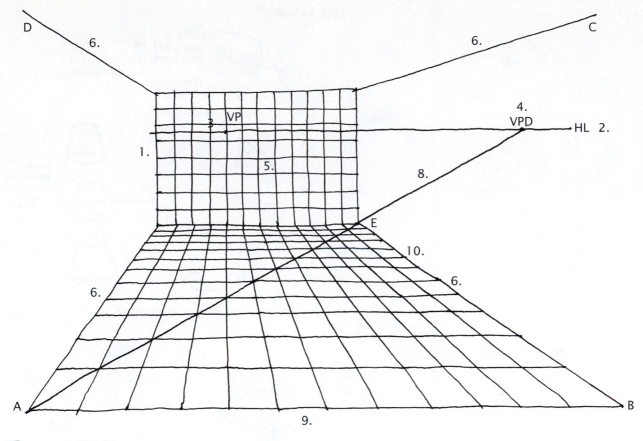

Figure 7.4
ONE-POINT EYEBALL METHOD, STEPS 1–11

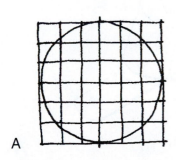
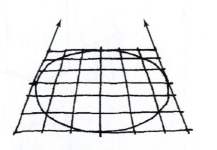
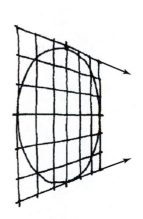

A CIRCLE IS ALWAYS AN ELLIPSE IN PERSPECTIVE

Figure 7.5
CIRCLE IN PERSPECTIVE

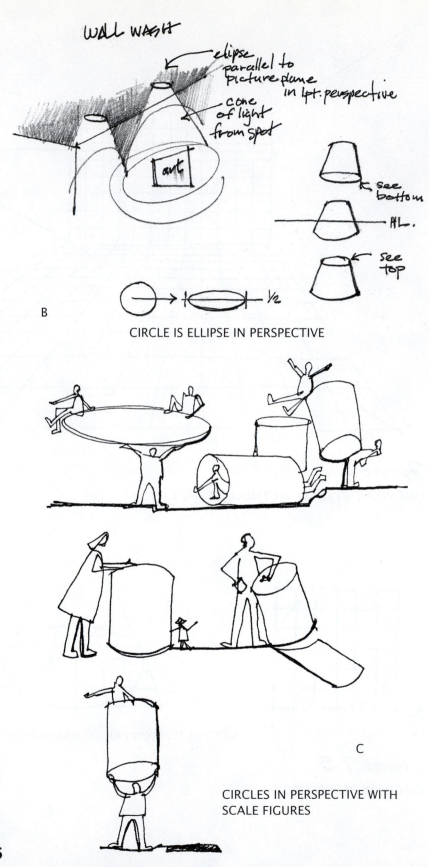

WALL WASH

elipse
parallel to
picture plane
in 1pt. perspective

cone
of light
from spot

art

see
bottom

H.L.

see
top

B

½

CIRCLE IS ELLIPSE IN PERSPECTIVE

C

CIRCLES IN PERSPECTIVE WITH
SCALE FIGURES

Figure 7.5
(continued)

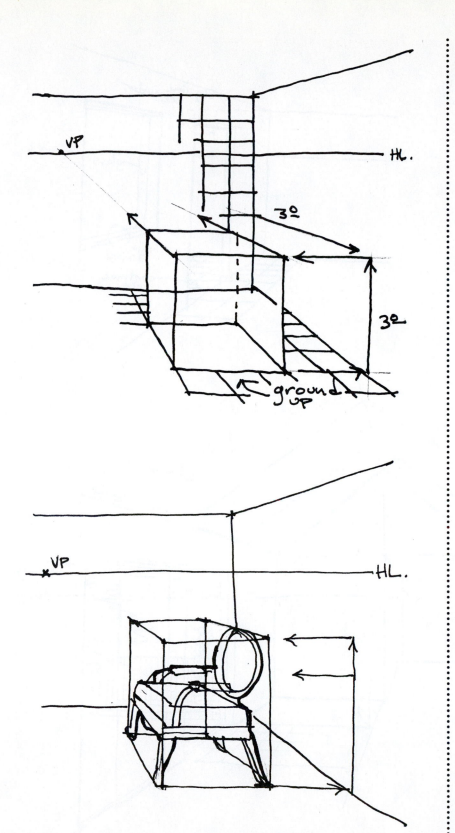

Figure 7.6

BASIC GEOMETRIC FORM ON ONE-POINT GRID

VP

HL.

3º

3º

ground up

Figure 7.7

BUILD A MORE COMPLICATED FORM FROM A BASIC ONE

VP

HL.

Figure 7.8

DOOR AND WINDOW ON ONE-POINT GRID

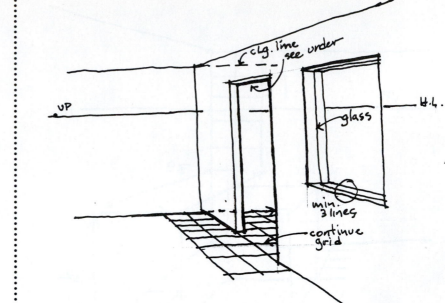

clg. line
see order

UP

glass

H.L.

min. 3 lines

continue grid

Figure 7.9

MORE COMPLICATED ARCHITECTURAL FEATURES ON ONE-POINT GRID

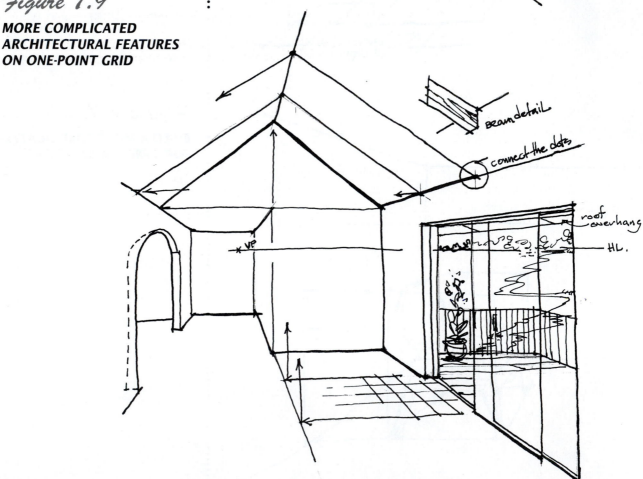

Beam detail

connect the dots

roof overhang

HL.

VP

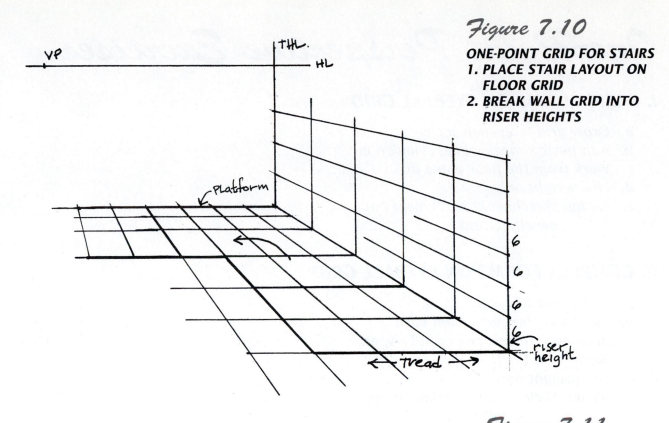

Figure 7.10

ONE-POINT GRID FOR STAIRS
1. PLACE STAIR LAYOUT ON FLOOR GRID
2. BREAK WALL GRID INTO RISER HEIGHTS

VP

THL.

HL

Platform

6

6

6

6

riser height

Tread

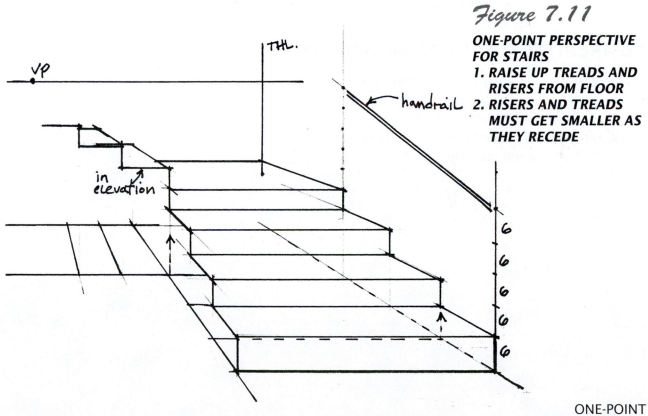

Figure 7.11

ONE-POINT PERSPECTIVE FOR STAIRS
1. RAISE UP TREADS AND RISERS FROM FLOOR
2. RISERS AND TREADS MUST GET SMALLER AS THEY RECEDE

VP

THL.

handrail

6

6

6

6

6

in elevation

ONE-POINT
EYEBALL
PERSPECTIVE

One-Point Perspective Exercises

I. BASIC FORMS ON EYEBALL GRID

a. *Draw grid to eyeball scale*
b. *Add basic shapes: cube, cylinder, etc.*
c. *Work from the floor plane up*
d. *Line weight only*
e. *Media: sketchbook, parchment paper*
 pencil, felt-tip

II. COMPLEX FORMS ON EYEBALL GRID

a. *Draw grid to eyeball scale*
b. *Build complex form from basic*
 geometric forms: chairs, tables, etc.
c. *Work from the floor plane up*
d. *Line weight only*
e. *Media: sketchbook, parchment paper*
 pencil, felt-tip

III. ARCHITECTURAL ROOM ELEMENTS

a. *Draw doors, windows, beams, etc.*
b. *Draw a basic run of stairs*
c. *Line weight only*
d. *Media: sketchbook, parchment paper*
 pencil, felt-tip

TWO-*POINT EYEBALL PERSPECTIVE*

8

What is two-point eyeball perspective?

Two-point perspective is ideal for viewing the corner or a more detailed view of a space since it cannot show the three walls of a space like one-point perspective can. Many believe that in certain spaces two-point perspective, even with its limitations, produces a more interesting or exciting view of the design. I prefer two-point perspective views to show exteriors of buildings.

Like one-point perspective, a two-point perspective may also be created using a quick eyeball or an eyeball method.

TWO-POINT QUICK EYEBALL METHOD

No scale is used. Once again, the height of the line is what you say it is.
Basic rules for two-point perspective apply.

1. Pick the corner line of the view selected. This will be your true
height line.

2. Select horizon line, approximately 3' 6" or 5' 6".

3. Place vanishing points on the left and right. The emphasis of the
view will determine which is closer in.

THL

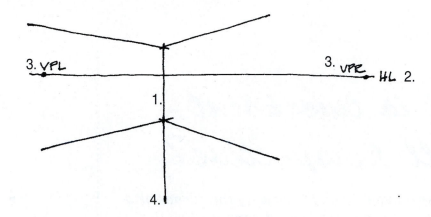

4. Select your depth reference. Remember: This is the same as the
THL.

5. Use the x geometric method to expand the space.

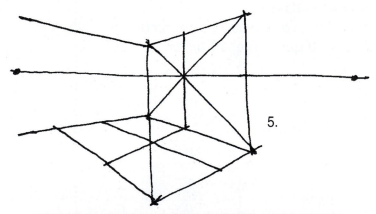

EXTERIOR VIEW WITH THREE HORIZON LINE CHOICES

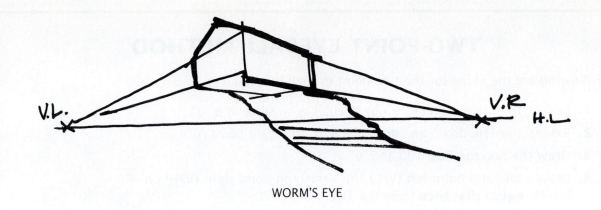

WORM'S EYE

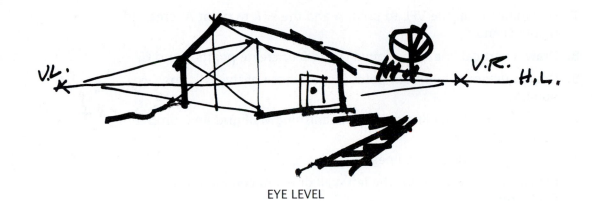

EYE LEVEL

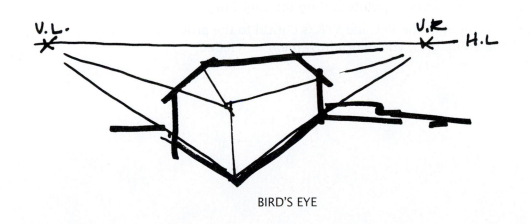

BIRD'S EYE

TWO-POINT
EYEBALL
PERSPECTIVE

TWO-POINT EYEBALL METHOD

Following are the steps for the two-point eyeball method (Figure 8.1):

1. Set the true height line (THL) by eyeball or to scale at 8′ 0″.

2. Extend the THL down an additional 8′ 0″ to create point A.

3. Draw the horizon line (HL) at 5′ 6″.

4. Draw vanishing point left (VPL) and vanishing point right (VPR) on the HL **equal distance** from the THL.

5. Draw the wall and floor planes from the VPL and VPR.

6. Draw the vanishing grid lines from VPL through the 1-foot to 8-foot points on the THL on the right wall.

7. Draw lines from the VPL to point A and the VPR to point A, creating points D and B.

8. Draw a vertical line from points D and B to create points E and C.

9. Draw a diagonal line from point C to the base of the THL, to point X.

10. Where the diagonal line cuts each vanishing wall grid line, drop a vertical grid line.

11. Draw the VPR floor grid lines.

12. Repeat the procedure for the left wall grid and complete the floor grid.

TO EXTEND THE WALL: Draw a diagonal line from the 4-foot point on the base of the wall through the 4-foot point on line BC to create point F, then drop new vertical lines at points cutting the vanishing lines.

Note: The placement of the VPL and VPR is critical to the proportion and distortion of the entire grid; you may adjust them as needed.

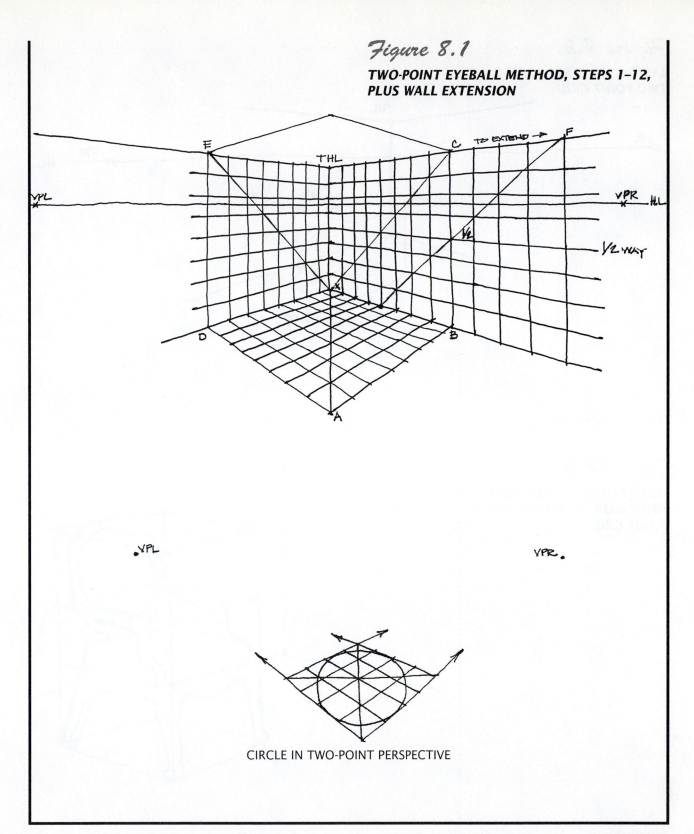

Figure 8.1

TWO-POINT EYEBALL METHOD, STEPS 1–12, PLUS WALL EXTENSION

CIRCLE IN TWO-POINT PERSPECTIVE

TWO-POINT
EYEBALL
PERSPECTIVE

Figure 8.2

BASIC GEOMETRIC FORM ON TWO-POINT GRID

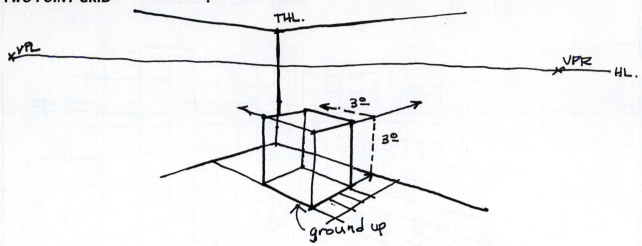

Figure 8.3

MORE COMPLICATED FORM FROM BASIC FORM ON TWO-POINT GRID

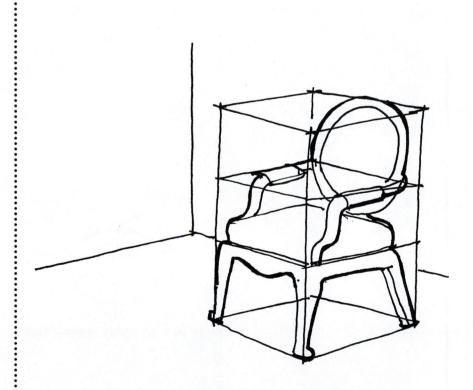

Figure 8.4

**DOOR AND WINDOW ON
TWO-POINT GRID**

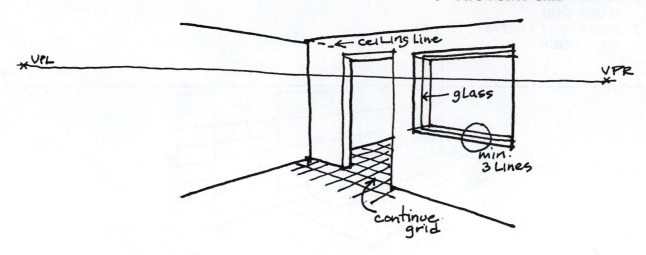

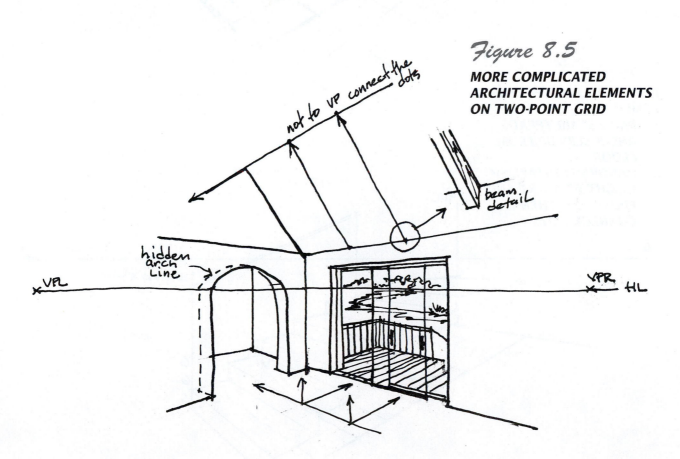

Figure 8.5

**MORE COMPLICATED
ARCHITECTURAL ELEMENTS
ON TWO-POINT GRID**

Figure 8.6

TWO-POINT GRID FOR STAIRS
1. **PLACE STAIR LAYOUT ON FLOOR GRID**
2. **BREAK WALL GRID INTO RISER HEIGHTS**

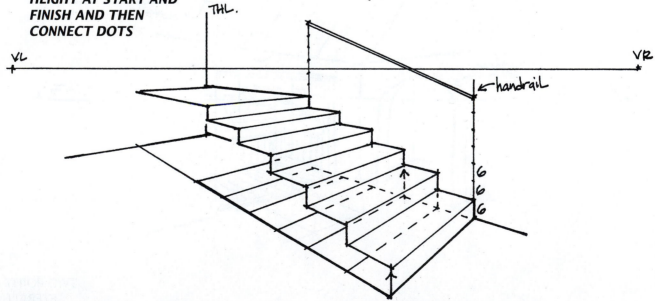

THL.

VL VR
 HL.

6
6
6
6
6
← riser height

Tread

Figure 8.7

TWO-POINT PERSPECTIVE OF STAIRS
1. **RAISE STAIR TREADS AND RISERS UP FROM FLOOR**
2. **HANDRAIL: ESTABLISH HEIGHT AT START AND FINISH AND THEN CONNECT DOTS**

THL.

VL VR

← handrail

6
6
6

Two-Point Perspective Exercises

I. BASIC FORMS ON AN EYEBALL GRID

 a. Draw grid to eyeball scale

 b. Add basic shapes: cube, cylinder, etc.

 c. Work from the floor plane up

 d. Line weight only

 e. Media: sketchbook, parchment paper,
 pencil, felt-tip

II. COMPLEX FORMS ON EYEBALL GRID

 a. Draw grid to eyeball scale

 b. Build complex form from basic
 geometric forms: chairs, tables, etc.

 c. Work from the floor plane up

 d. Line weight only

 e. Media: sketchbook, parchment paper,
 pencil, felt-tip

III. ARCHITECTURAL ROOM ELEMENTS

 a. Draw doors, windows, beams, etc.

 b. Draw a basic run of stairs

 c. Line weight only

 d. Media: sketchbook, parchment paper,
 pencil, felt-tip

TWO-POINT
EYEBALL
PERSPECTIVE

OVERLAY METHOD

What is the overlay method?

The composition studies must be completed at this point to provide us with the best view of what to show to communicate our design decisions to the client. These composition studies save valuable time in the long run and lay the foundation for a strong final result.

A good composition is by far the most critical part of a presentation drawing. In fact, compositional decisions should become second nature from the quickest sketch to a 20-hour rendering.

Once the best view provided by a one-point or two-point composition has been selected, we are ready to begin the overlay method. The term *overlay refers to the use of tracing paper over a series of studies to arrive at an end result.*

STEP 1. COMPOSITION STUDIES

Composition studies play a vital role in developing a final-level perspective drawing for a client. Obviously, at this stage in the design process we already have a final floor plan and the furniture and furnishings have been selected. At this stage the selection of a view that best communicates the design is critical, and a well composed drawing allows the renderer to enhance it with tone/shadow, texture/materials, and color.

As part of the composition studies, some basic rules for good composition should be followed.

Balance

A drawing should always be in balance. The two basic types of drawing balance are symmetrical and asymmetrical, which are basically the same as in the principles of design. A symmetrical composition is less

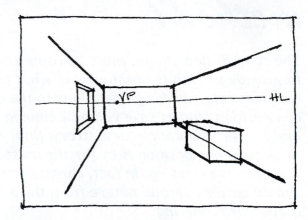

Figure 9.1

BASIC PERSPECTIVE VIEWS EMPHASIZE CHANGES WITH MOVEMENT OF VANISHING POINT

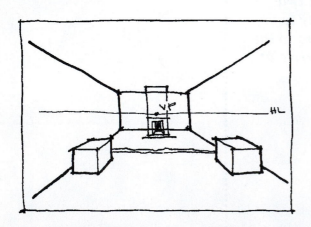

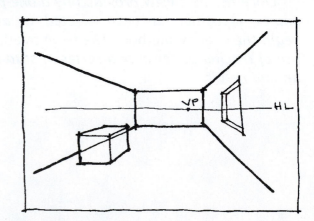

dramatic or exciting than an asymmetrical one, but if the design is symmetrical then the drawing should be used to express this quality. Remember: If you are using figures in a drawing, they have visual weight and can be a positive factor in achieving balance.

Emphasis

Emphasis is the factor that determines how we express the visual impact and important features in the space. Here the term **focal point** is used to indicate the strongest visual feature in the drawing or design. It may be a fireplace, a major piece of art, or some other important architectural or design feature. The focal point is usually placed in the midground of the composition. If there is no specific focal point, a focal area may be indicated (Figure 9.1).

Positive or Negative Space

The careful use of positive or negative space is essential to the balance of the drawing. Too much negative space in the composition can weaken the impact or throw the drawing out of balance. Human figures can be used to help with this problem.

Foreground, Midground, and Background

Attention to these areas in a drawing will stimulate viewers to move their eyes actively through the space. Foreground is defined by any element, object, or form that penetrates the picture plane. We generally think of foreground objects as being found only in the lower front of a composition; however, they may be placed at any point around the perimeter as long as they penetrate the picture plane. The only critical decision is how much of an object to cut off, and this is generally based on proportion and the ability to still be able to identify the object. A drawing may be effective without an actual foreground, but the presence of a foreground can increase the believability that the viewer is in the space. The midground should be the strongest part of the composition since it should contain the focal point or focal

area *that enhances the emphasis in the design. The* background *in the composition produces the visual effect that carries the eye beyond the basic space shown, for example, looking out a window or into an adjacent space. Once again, in some compositions it may not be possible to use background as a feature but the end result can still be effective.*

Composition studies are a requirement when using the overlay method. Time and budgetary constraints do not permit us the freedom to do unlimited perspective views. So limiting our composition studies, doing them quickly, in single line, and in small size is imperative. An eyeball method can save time, as can drawing in line only, since at this time we are concerned only with building a strong composition that will serve as the foundation for the rest of the overlays. We will be using only one-point and two-point perspective alternatives, selecting standard 3′ 6″ (for seated eye level) or 5′ 6″ (for standing eye level) horizon line heights and typical vanishing point placements. However there should be enough freedom in each design to select from compositional choices that best express its features.

Two to four studies are usually enough to make our final choice, although sometimes variations or combinations will be developed into the final composition (Figures 9.2 and 9.3). While working on the composition it is easy to use tracing paper overlays in a preliminary manner to study various alternatives related to line, light, and texture with the use of more contrast. Or, if there are challenging features such as views out windows, now is the time to experiment with them (see Chapter 10, Entourage). On average, the size need be no bigger than 5″ × 8″ and a time frame of less than an hour is desirable. However, since a good composition is the foundation for all that follows, the time spent on these studies is worthwhile.

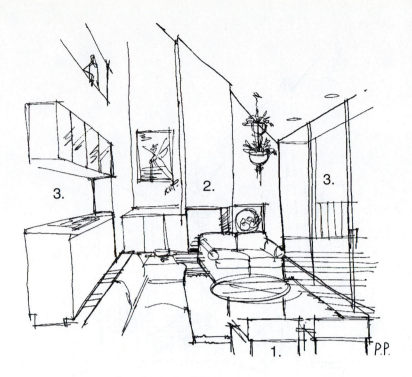

Figure 9.2

**ONE-POINT COMPOSITION
STUDIES SHOWING:
(1) FOREGROUND,
(2) MIDGROUND, AND
(3) BACKGROUND**

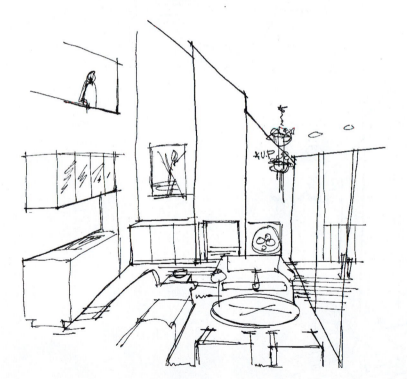

Figure 9.3

TWO-POINT COMPOSITION STUDIES

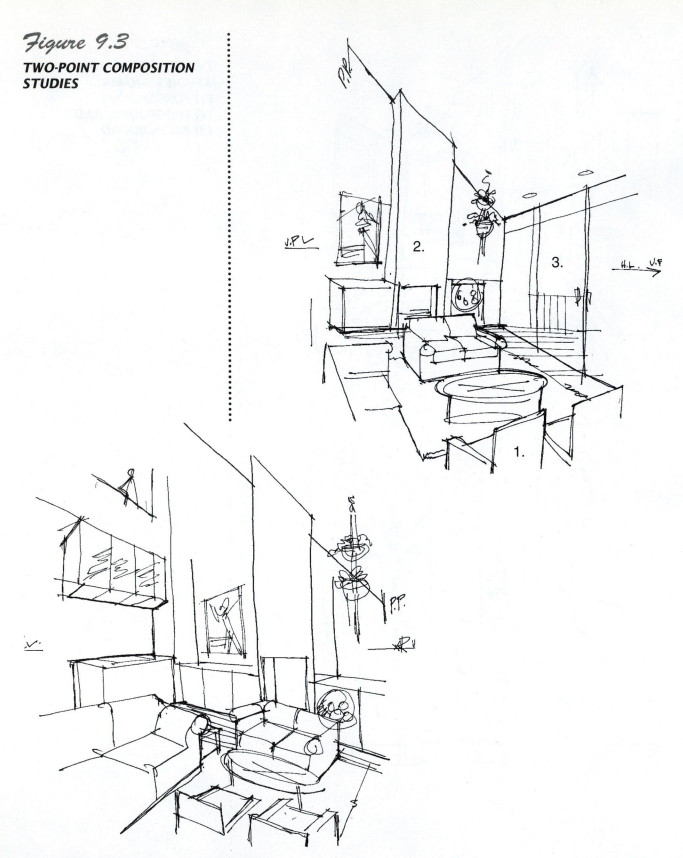

STEP 2. SINGLE-LINE BLOW-UP

The first step is to convert the composition study to the size it will be for final presentation. The perspective may have been created by an eyeball method or a mechanical method (not part of this text). The style may be loose and sketchy or tight and controlled. You must be concerned with both line quality and weight in this single line drawing (Figure 9.4).

STEP 3. TONE/SHADOW STUDY

Place yellow or white parchment tracing paper over the single-line blow-up. The media used for this can be pencil, pen, fine liner, or marker. Now select your light source: natural, artificial, or a combination. Use sunlight when possible since it produces the most lifelike shadows.

Figure 9.4

OVERLAY METHOD: SINGLE-LINE BLOW-UP

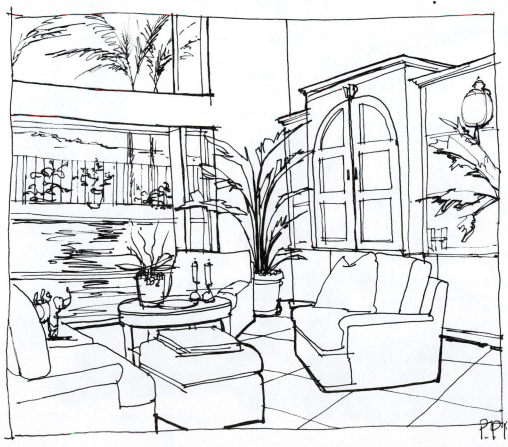

First apply your tones, starting with the broad planes: walls, floor, and ceiling. Remember: The most successful values move from 0 to 10, or white to black. Be sure to save your black for the shadows. Marker is a light-to-dark medium. **Note:** Do not retrace your lines; use tone only (Figure 9.5).

Next apply the shadows. Since these are studies, do them as quickly as possible and feel free to experiment with your light sources. You should never experiment on a final drawing; now is the time. Shadows can be strong, bold, and geometric in style or soft and subtle; you be the judge in each drawing.

Figure 9.5

OVERLAY METHOD: LIGHT STUDY, TONE/SHADOW

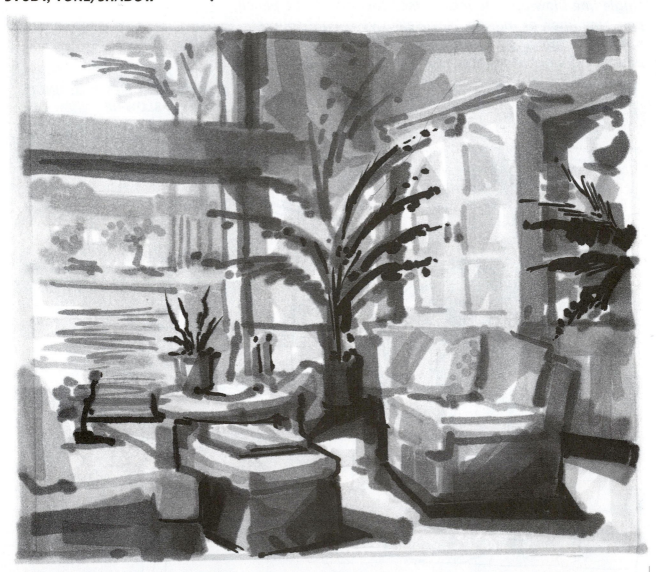

Since you don't want to color only between the lines—creating what I call the **coloring book effect**—you can often use two tones meeting to create the line, thus eliminating the **redundant line**.

Most beginners are not nearly bold enough with tone and shadow. It is a good idea to back away from the drawing and look at it from a distance to check the visual impact. This is still one of the easiest areas to improve upon.

STEP 4. TEXTURE/MATERIALS

Once again, place your tracing paper over the line drawing for this overlay. All of the elements in a space have texture; this study will help you decide what to emphasize in the drawing (Figure 9.6). Since drawing texture and materials can be very time consuming, you can use techniques to let the eye of the viewer complete some of the imagery for you. There are many entourage books that include a variety of real and generic textures for your use. However, since there is no single correct way to create texture, you may feel free to develop your own method; whatever works is correct.

Remember that texture is an element of design that can create visual interest and stimulation. It can give a space its character from rustic to high-tech. It employs the design principles of unity and variety.

STEP 5. THE FINAL PERSPECTIVE DRAWING

This is the sum total of the best of your overlay studies (Figure 9.7). The drawing will be part of your client-oriented presentation. The end result is often tied to budgetary constraints and time. Generally, only major-scale projects have money allocated to this type of drawing. This is a shame since, in the long run, the information these drawings convey will inevitably save money when changes must be made.

The umbrella that defines final drawings is very broad. Sketch styles vary from tight and mechanical, black and white, full or part color, and vignette to full frame. All of the examples of my final drawings shown

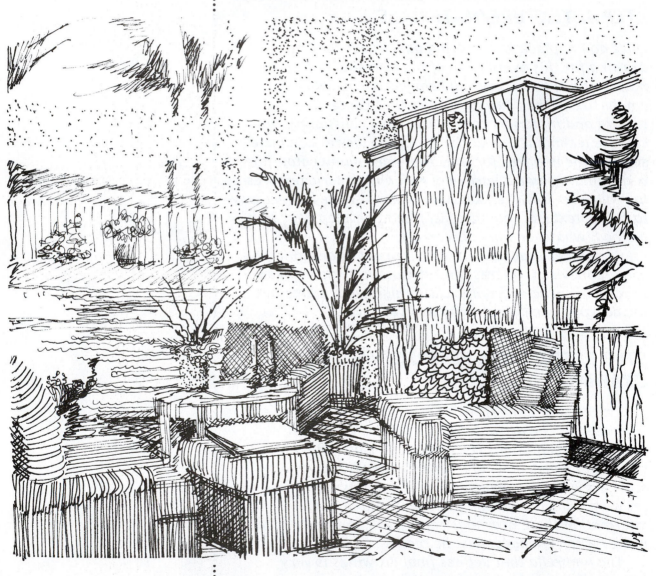

Figure 9.6

OVERLAY METHOD: TEXTURE/MATERIALS STUDY

here are eyeball *or a variation thereof. The size, complexity, and medium usually dictate the cost.*

A good final drawing can assure clients that they are getting what they want. The role of the renderer is to portray the design as accurately as possible and be as flattering as possible. But we must not misuse our skills just to please through the many tricks of the trade; to be fair to the client, we must maintain our integrity through the use of this art form.

Figures 9.8 through 9.13 are examples of preliminary and final perspective drawings.

Figure 9.7

OVERLAY METHOD: ALL STUDIES COMBINED INTO FINAL DRAWING

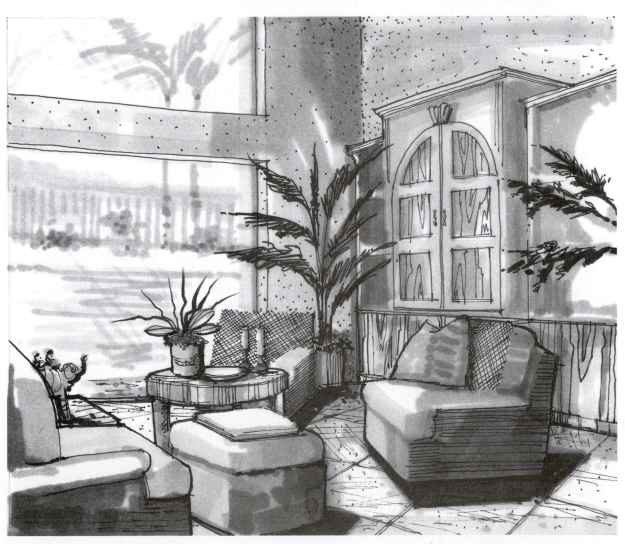

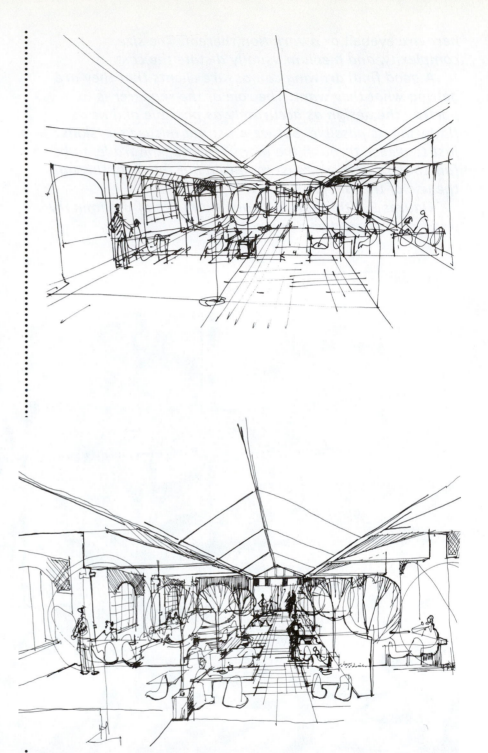

Figure 9.8A

PRELIMINARY STUDY FOR FLORIDA A&M UNIVERSITY DINING HALL

Figure 9.8B

REFINED STUDY FOR FLORIDA A&M UNIVERSITY DINING HALL

Figure 9.9

FINAL PEN-AND-INK DRAWING FROM FIGURES 9.8A AND B

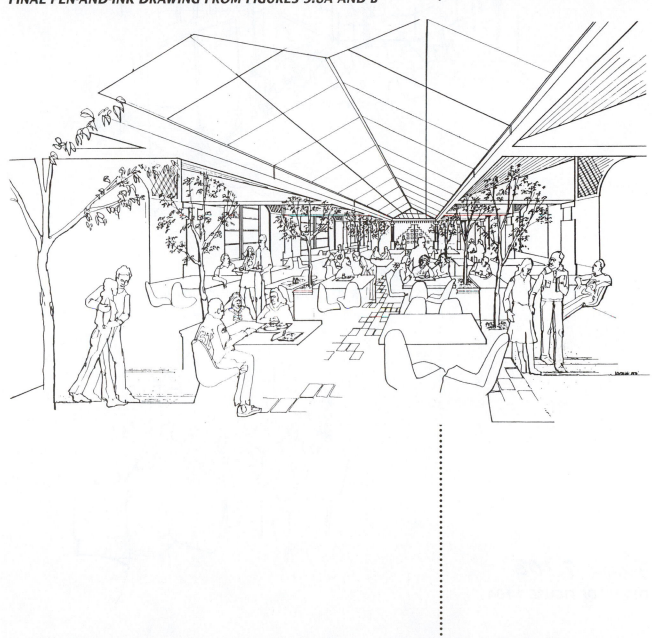

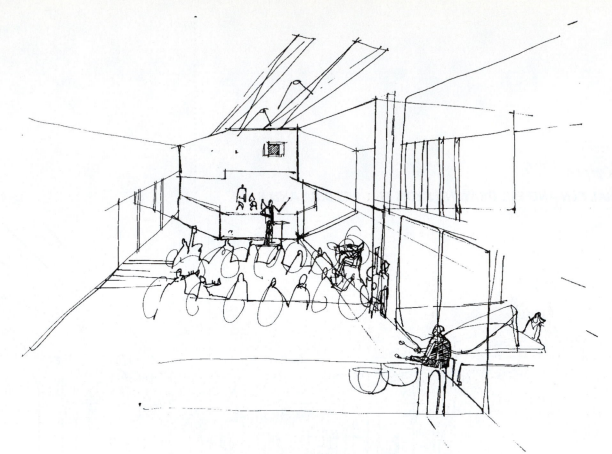

Figure 9.10A

STUDY FOR PEGASUS RECORDING STUDIO

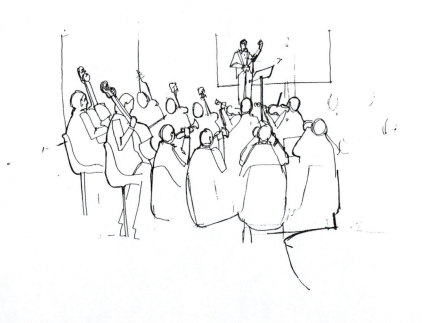

Figure 9.10B

DETAIL OF FIGURE 9.10A

Figure 9.11

**FINAL PEN-AND-INK RENDERING FOR
PEGASUS RECORDING STUDIO**

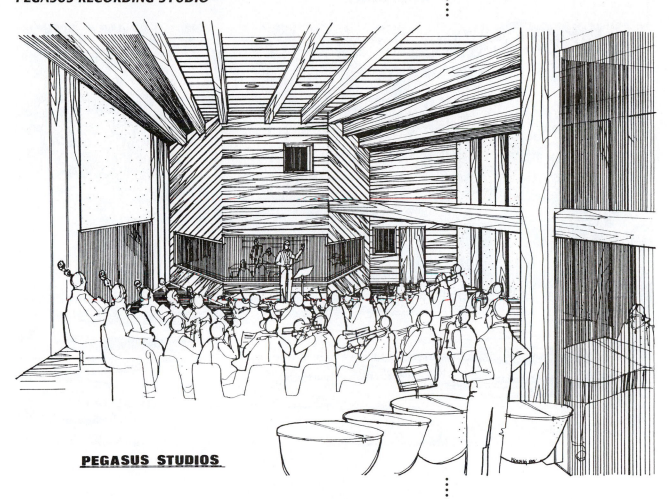

PEGASUS STUDIOS

Figure 9.12

FINAL PEN-AND-INK RENDERING OF A RESIDENCE

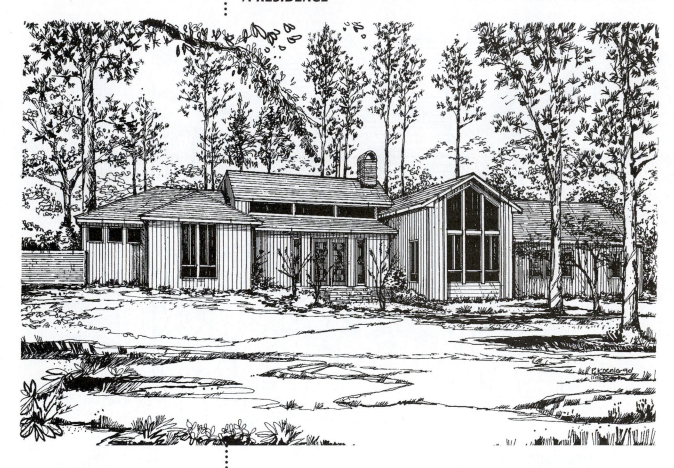

Figure 9.13

FINAL PEN-AND-INK RENDERING OF A MARINA

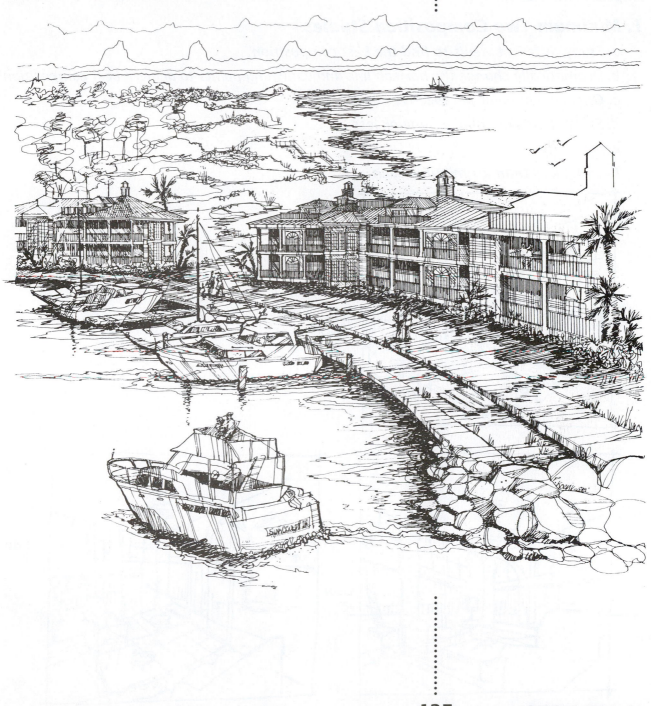

Overlay Method Exercises

REQUIREMENTS:

Sketchbook or parchment paper; final on graphics paper; pencil or felt-tip with markers on preliminary or final

1. Minimum Two Composition Studies

 a. Study different views to find the best composition

 b. Dramatically change the horizon line and vanishing points to achieve best composition

 c. One- or two-point perspective views

 d. Small: half sketchbook page or less

 e. Line only

 f. Time: less than 20 minutes each

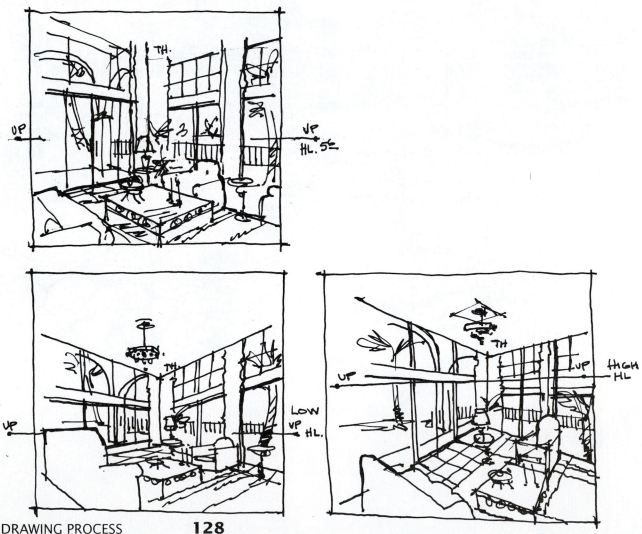

2. Single-Line Blow-Up

a. Select the best composition study to work from

b. Blow up to size needed for the final project

c. Line only

d. Eyeball grid method (scale as needed)

e. Parchment paper

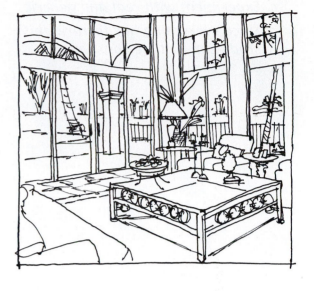

3. Tone/Shadow Study

a. Work on parchment paper over single-line blow-up

b. Do not *redo* lines; tone and shadow only

c. Put value on the broad planes first

d. Select a light source or sources. Natural light works best

e. Put value on furniture and furnishings

f. Save shadow for last (save 10 value for shadow)

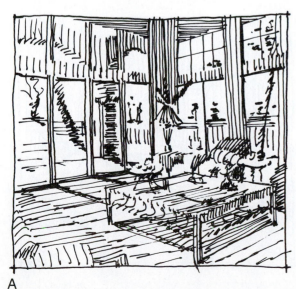

A

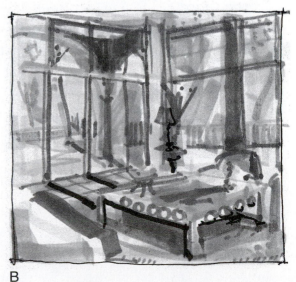

B

4. Texture/Materials Study

a. Work on parchment paper over single-line blow-up

b. Texture and materials only

c. Experiment with real and generic

d. Since everything has texture, this study can be time-consuming

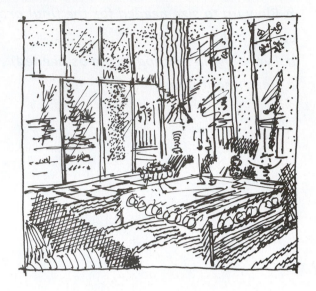

5. Final Drawing (Putting All the Studies Together)

a. Use the best of line weight and character as needed

b. Use tone and shadow for punch, readability

c. Use strongest texture and materials (remember to apply texture over tone) to add a tactile sense to the space

d. Add entourage plus figures to humanize the space

e. This drawing will be for the client. The time you spend will vary by size, style, and budget.

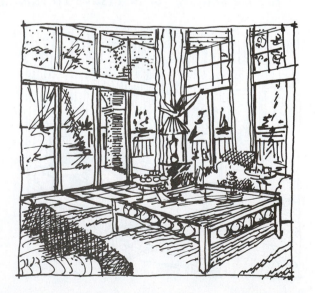

DRAWING PROCESS **130**

ENTOURAGE

10

What is entourage?

Entourage *refers to all the elements in a drawing that humanize it or bring it to life. In fact, several books on the market today are dedicated exclusively to entourage as a tool for the drawing student to copy or use as a tracing file. The books show predominantly figures in a variety of scales and poses, as well as plants, trees, cars, and miscellaneous elements found in exterior and interior drawings. Many of these elements allow us to use the skills we learned in freehand sketching, which adds a nice, loose touch to the drawing.*

These books have their place in drawing education, but you should avoid using them as a crutch to replace practicing and learning to draw the things they offer.

Figure 10.1
FIGURE SCALE EXAMPLE

THE HUMAN FIGURE

The human figure should play an essential and vital role in sketching, design drawing, and final presentation perspectives. The style and type of figure may vary depending on the purpose of the drawing.

The best way to learn to draw the human figure is to use real-life models. To develop an understanding of the human figure, you can learn a lot by simply studying some basic anatomy. I tell students who feel the human figure is just too difficult to learn to draw that if they can learn to draw a complex piece of furniture by looking at it carefully and observing its form and details, they can learn to draw a human figure with practice.

In design drawing it is essential to use figures to establish scale and proportion (Figure 10.1). There are several typical styles that meet our information needs.

Even at relatively small scale, the quick-sketch-style figure can be very effective in displaying the anthropometric relationships involved in your design solutions. People tend to relate everything in their environment to themselves, which makes the use of the human figure even more important.

The human figure in final presentations, in both residential and nonresidential projects, can play an important role. However, in residential presentations they often pose a real dilemma, for unless we use truly generic figures we can face the pitfall of trying to draw the figure to resemble the client. This can create some potentially embarrassing situations. In nonresidential or commercial projects, on the other hand, using figures can show the space functioning and bring it to life. Figures can play a basic role in establishing a stronger composition. They are a strong source of form, and a vertical figure can have the visual weight of a column in both interior and exterior views. Triangulating the placement of figures from the foreground to the midground to the background provides a sense of scale and an illusion of depth in the composition.

Avoid using large foreground figures in the center of the front. Since they will need to be perfectly drawn, they

may distract the viewers' attention from the rest of the space, or they may block important features. Even worse is using a large foreground figure from the rear view. Also stay away from poses that even an accomplished artist would avoid, for example, a figure seated front face.

Figures should appear as if they belong in the space, placed in poses that would appear natural for the scene shown. Since most people find drawing the heads, hands, and feet to be the most difficult, I recommend that you group figures or place them in relationship to furniture in ways such that a minimum of these body parts are visible (Figure 10.2). Tracing figures from an entourage book is an acceptable method, but care must be taken since the authors of such books usually have excellent drawing

Figure 10.2
FIGURE PLACEMENT STUDY USING TRIANGULATION, ON YELLOW TRACING PAPER

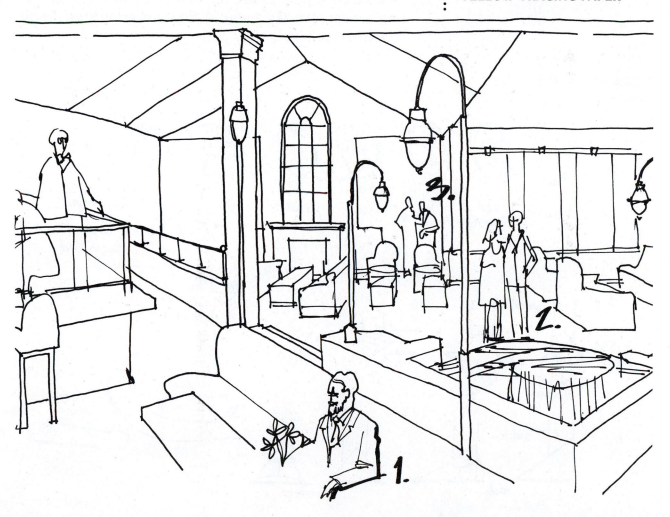

Figure 10.3
TRACING OF FIGURES

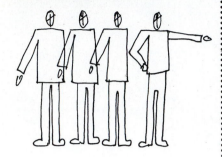

skills. Perfectly tracing their figures may make them stand out in your drawing for a variety of reasons. Here are several suggestions for avoiding this pitfall:

1. Draw your own figure directly next to the one in the book (Figure 10.3).

2. Trace the figure, then retrace your tracing several times. This will allow you to express some of your own line character and style, thus making the figure fit more naturally into your final drawing.

3. Change a part of the original pose by moving an arm or leg, once again adding something of your own to the figure's character. Avoid rubber arms and legs; see Figure 10.4.

4. Finally, select up-to-date hair styles and clothing and be sure the figures are appropriately dressed for the space you are designing. A figure overlay study may be extremely valuable.

Figure 10.4
DRAWING BASIC HUMAN PARTS

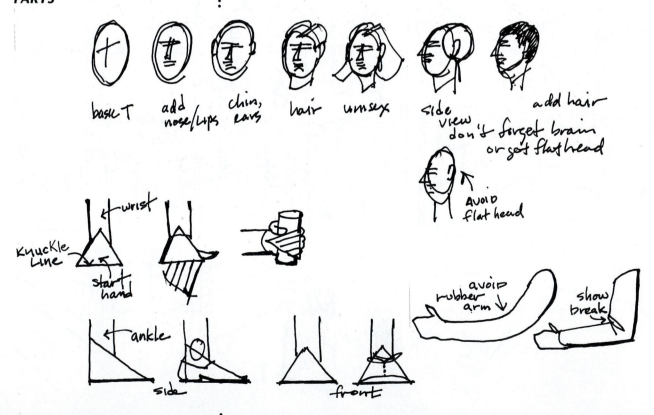

Figure 10.5
BASIC RELATIONSHIPS

avoid

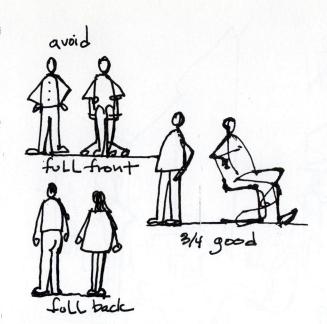

full front

3/4 good

full back

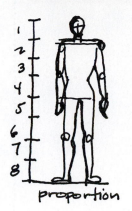

proportion

1
2
3
4
5
6
7
8

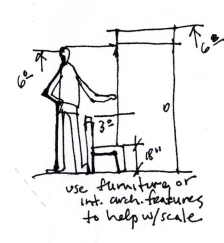

use furniture or
int. arch. features
to help w/scale

6°
6°
3°
18"

interaction

hide
hands

overlap
figs.

feet

Gestures Studies

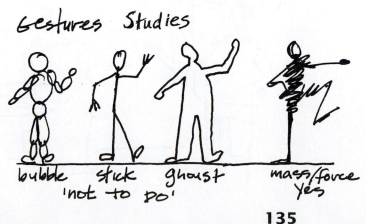

bubble stick ghost mass/force
'not to Do' yes

135

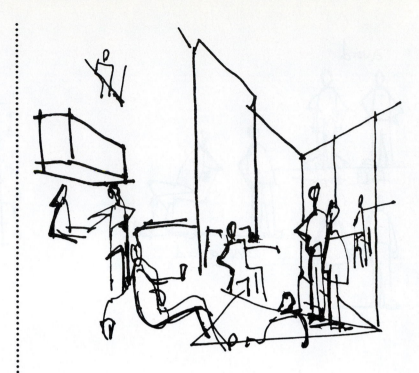

Figure 10.6

TRIANGULATION AND FIGURE PLACEMENT STUDY

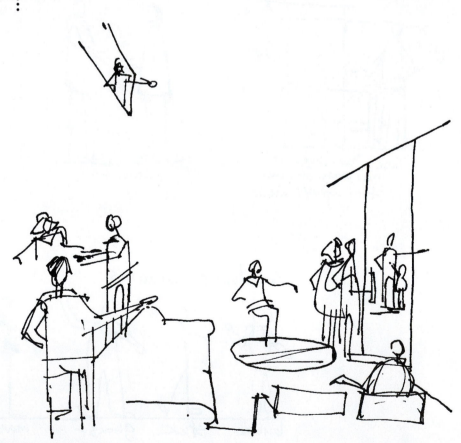

A

B

C

D

Figure 10.7
FIGURE STUDIES

137 ENTOURAGE

STUFF FOR SKETCHING

Stuff *refers to everything else one finds in common exteriors and interiors that makes them look like someone lives or works there. Stuff shows that the spaces drawn are a real part of the daily environment. In exteriors we find such things as cars, buses, signs, lampposts, and fences. In interiors we find books, telephones, magazines, glass and tableware, and—most important—artwork. Paintings, wall art of all types, and sculpture often add real strength and credibility to the designed space (Figure 10.9). This list of stuff goes on and on but, as you can clearly see, anything that can be utilized to humanize the spaces we design gives the feeling that these spaces really exist. The things we choose to study, whether they are interior or exterior, comprise a **still life.** You must compose the drawing the same way a photographer or artist would, while continuing to concentrate on line, tone/shadow, and texture/materials.*

The proper use of entourage as illustrated in the three sections of this book is one of the most important parts of drawing for design and the client communication process. In the final analysis, human beings are our clients and the source of our livelihood; they are who we design for. So the humanization of our drawings, first practiced in sketch format, is not merely a source of drawing pleasure for us but is critical to the client recognition factor and to achieving success in our role as a designer.

Figure 10.8B

STUFF EXAMPLES

Figure 10.8A

STUFF WITH TEXTURE

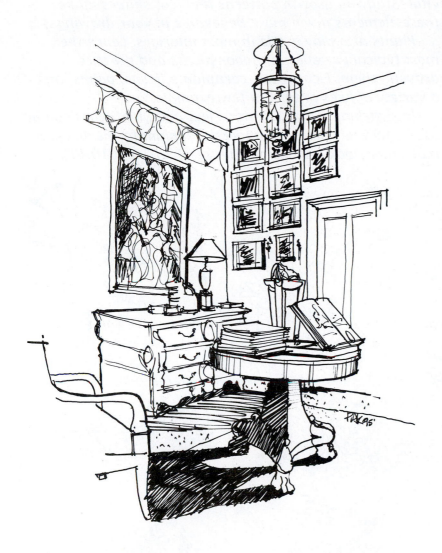

Figure 10.9

**TWO-POINT IMAGE
PERSPECTIVE WITH ART
AND ACCESSORIES**

TREES AND PLANTS

Trees and plants in exterior drawings are an excellent source of free-form lines and texture. They react strongly to natural light, creating strong shadow patterns. Once again, drawing on site and practicing what you see is vital. Studying growth patterns and leaf shapes makes these elements much more believable in your drawings.

Plants also play a role in most interiors. Learn the most typical varieties of indoor plants and practice drawing them. Ficus trees, cornplants, ferns, palms, and a variety of ivies are just a few examples.

In sketching, several generic leaf and plant types can be used effectively once you understand plant forms and can make them look convincing (Figures 10.10 and 10.11).

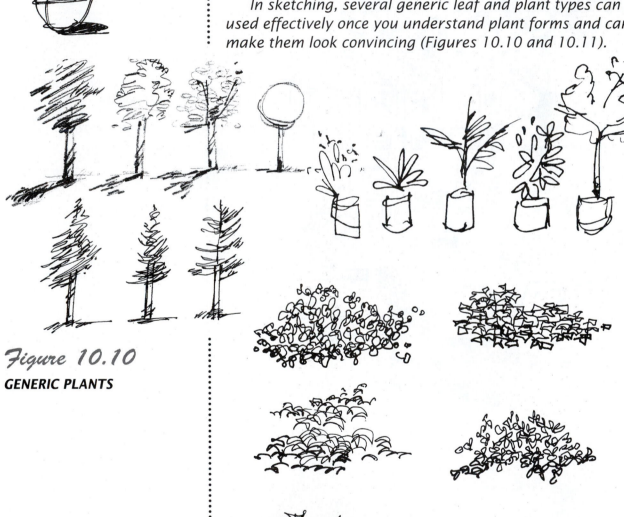

Figure 10.10
GENERIC PLANTS

Figure 10.11
GENERIC LEAF EXAMPLES

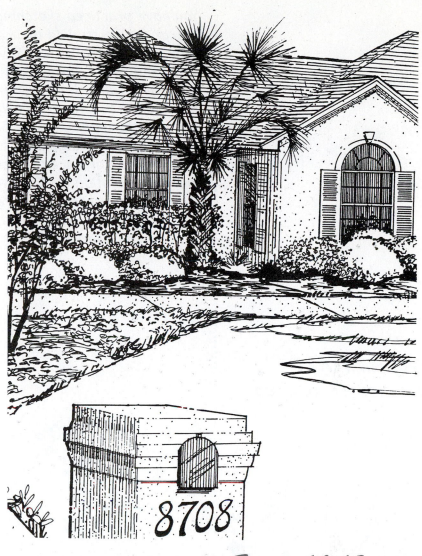

Figure 10.12

BLOW-UP FROM RESIDENTIAL RENDERING

You have practiced sketching real trees and plants from life, and have studied their growth patterns and how light affects them. Plants play a vital role in interior design and using real plant varieties in your drawings makes them more believable. Interiors that have windows need to maintain the drawings' horizon line and express a true sense of the exterior view. Generally, the value and detail of the scene and objects outside should be muted and have less detail since the designer wants to keep the viewers' attention on the interior spaces. Although reality is important, proper use of generic textures for planting can be both effective and, sometimes more important, time saving (Figure 10.13).

Figure 10.13

EXTERIOR PLANTING AND MATERIALS

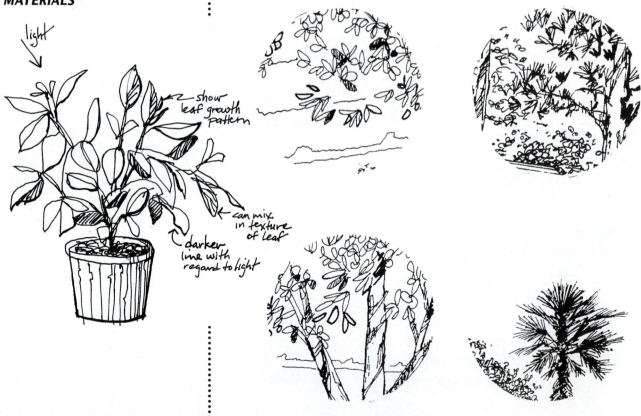

light

show leaf growth pattern

can mix in texture of leaf

darker line with regard to light

ART

Art is often a critical part of a residential or commercial design (Figure 10.14). It is best to not try to make your drawing of artwork too literal. In many cases, the final art has not been chosen at the time of your presentation. Therefore, placing the right type of art for the space is as important as figure selection. For example, one would not expect a realistic landscape painting in a high-tech interior. Basically, keep the wall art or sculpture simple; give it character without too much detail. Entourage is the last thing added in the overlay method, but it may well be the most important. Viewers are most comfortable with things they recognize. The humanizing aspects of these objects can go a long way in your communication to the client. The design solutions you have presented through your drawings will reinforce their decision in selecting you to creatively solve their problems.

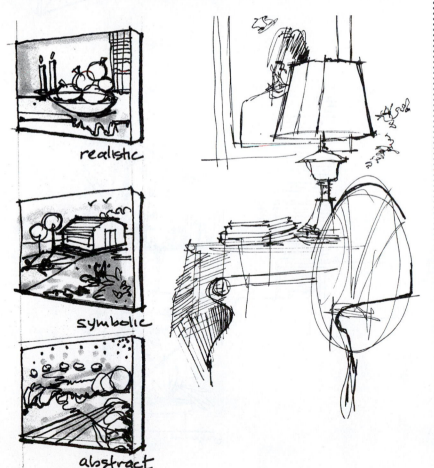

realistic

symbolic

abstract

Figure 10.14
SKETCH WITH ART

Figure 10.15
OUT-THE-WINDOW STUDY

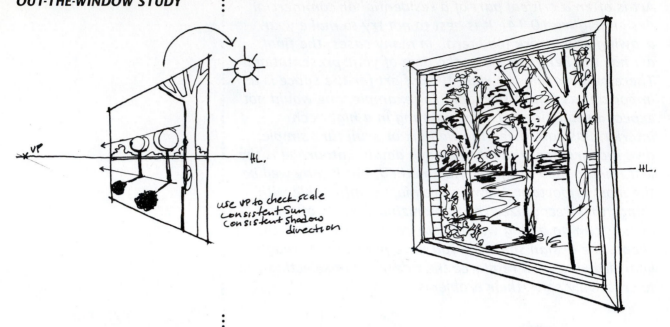

use VP to check scale
consistent sun
consistent shadow
direction

Figure 10.16

TEXTURE, FOREGROUND OBJECT, OUT-THE-WINDOW STUDY

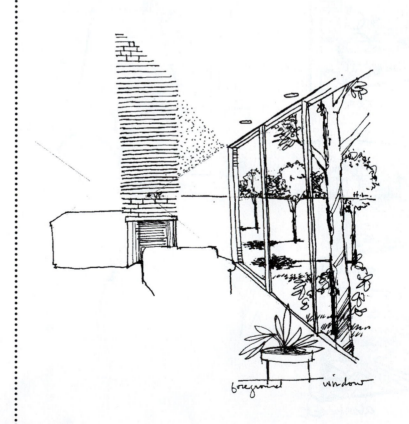

foreground window

Entourage Exercises

I. FIGURE DRAWING

1. Gesture Drawings

Gesture drawings are an excellent beginning figure exercise. They help you "learn to see" and give you the chance to "loosen up." In the classroom you can use other students as models; at home, use friends or family members.

The time for this exercise should be from 30 to 90 seconds. The goal is to capture the gesture of the pose, the forces of movement, and the sense of equilibrium. The pace is fast, so use a soft lead pencil or a felt-tip pen; don't outline the figure, but use bold lines and a sense of mass.

Since 30 seconds is a very short time, your model can hold almost any active pose. In fact, some of the best models are students who have studied ballet or karate. Two models posing together may make for some interesting results.

In the gesture drawing, human form or clothing details are simply not important; there is simply not enough time to cover those elements.

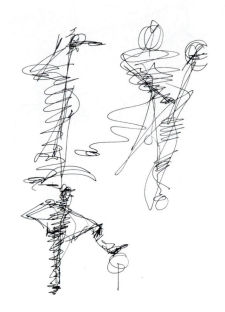

2. Figure Study

Changing the time of the pose to 1½, 3, and 10 minutes, for example, allows you to see how much can be accomplished in short time-span jumps. The shorter time spans still maintain gesture quality while allowing for some observation of human form and clothing. At 10 minutes you can concentrate on more detail and more expressive line quality (character). Of course the type of pose changes with the length of time and becomes simpler on the scale of complexity of human movement. These studies increase your ability to "learn to see" and your hand/eye coordination while supporting the importance of the figure in the drawing process for communication.

Media: Sketchbook pencil, felt-tip
Size: Gestures ½ page
Figure studies ½ to full page

II. HAND/EYE COORDINATION EXERCISE

1. No Lift

No lift is one of the two most popular hand/eye coordination exercises.

Look at the subject and start drawing anywhere without lifting your sketch tool off the paper. Use line only. You may alter the pressure to change line weight, but in this exercise you are not concerned with tone/shadow or texture.

Draw the line relatively slowly. You are not working at the speed of a gesture drawing so you have more control.

Although this drawing will never be literal, your accuracy will improve with practice. The average time allotted to this drawing is 1 to 5 minutes.

2. No Look

No look is the second most popular and most challenging hand/eye coordination exercise. It requires great patience and self-control; even the best renderers are frustrated by it.

Look at the subject and start anywhere but don't look at your drawing at any time. The pace is slow, but be confident and do not worry about accuracy.

You can lift your drawing tool from the paper, but since you can't look you will probably lose your place and not regain it. If you look at the drawing at any time during the exercise, the exercise is over.

Time for this exercise is usually 1 to 5 minutes.

Again, you are using only line and are not concerned with tone/shadow and texture. Practice this technique in the classroom or at home, and if the results are even close to resembling reality, you have done quite well.

Media: Sketchbook
pencil, felt-tip
Size: ½ page

III. Stuff and Art

Draw a variety of stuff in residential and commercial spaces.

a. Include art, plants, books,
accessories, etc.

Art: Show realistic, symbolic, and
abstract alternatives

Plants: Study real plant types: ficus,
rubber, etc.

b. Use hand/eye sketches or eyeball grid

c. Media: sketchbook
pencil, felt-tip, marker

IV. Out-the-Window

Draw both one-point and two-point perspective windows:

a. Draw complete window frame
accurately

b. Maintain horizon line and vanishing
points

c. Show a consistent light source for
exterior shadows

d. Show both natural and urban scenes

e. Use hand/eye sketches or eyeball grid

f. Media: sketchbook
pencil, felt-tip, marker

PRESENTATION

11

What is presentation?

Presentation *is the method we use to display our design drawings to the client. Presentation and its success or failure has absolutely nothing to do with your ability to draw or design. Of course successful presentation skills will certainly prove beneficial to the designer, while mistakes in judgment or craftsmanship will be a negative or distracting factor.*

In the past, the most popular method of presenting design drawings was to mat them. This is a time-consuming and often very expensive presentation method.

Basically, the best method of presentation is often the simplest. In fact, drawings may simply be mounted directly to a backboard or presented on individual sheets of paper that may be protected with a lamination process and later placed in protective folders in the portfolio. However, using strip mats on either the top and bottom or bottom only is still popular and far more economical.

Mats are used to frame the drawings and contain the eye, creating a more formal and finished look. Two critical factors in matting are proportion and color. Proportion varies as it is directly related to the size of the drawing.

Based on optical illusion, the bottom section of a mat should always be slightly larger to maintain visual balance. When choosing a color for a mat, be sure to place a sample of the board next to your drawings to get the correct value and intensity.

Neutral mat colors are usually the best choice; in fact, a white or black mat or possibly a value of gray is preferable with a black and white drawing. Also, if warm or cool markers are used in the drawing they will determine the color of gray selected for the mat. Use caution when selecting a black mat since it may overwhelm a subtle drawing.

Colored mats will likely distract from a monochromatic drawing. Although color is not the subject of this text, it is recommended that you match the color of the mat to a color in the drawing. You need not match the exact color; instead choose the value and intensity of the color that works best to set off your work. Although presentation methods have not changed much in the past few years, there has been a trend toward simplification: projects and portfolios are smaller and less matting is used on drawings.

Following are some key concerns in presentation:

1. **Craftsmanship.** Craftsmanship is vital since sloppiness can affect the attitude of a client toward all of your work. Drawings that are not spaced evenly or have poorly cut mats are clearly distracting to the viewer.

2. **Composition.** Compose and balance your boards and use implied margins as needed. This not only aids in continuity but makes complex drawings more easily defined and readable.

3. **Title information.** Select title information and style carefully. Typeface selection and size are very important for emphasis. The placement of written information helps with balance and emphasis. Be consistent with centering and right or left margins.

4. **Consistency in presentation.** Place the boards in a consistent direction, either vertical or horizontal. Also be consistent with your choice of media, which may be mixed. Develop a consistent drawing style.

Figure 11.1 shows examples of presentation methods.

Presenting your drawings and design is the final step that brings everything together. Your efforts at this point can have only one of three results: they will (a) help you, (b) hurt you, or (c) do nothing either way. Obviously, since you are spending valuable time and money on your presentation, the decisions you make should result in the first option. Nothing you do should ever have a negative or distracting effect on the viewer. Final presentation techniques and choices should communicate your design efforts clearly, cleanly, and positively.

Figure 11.1

EXAMPLES OF PRESENTATION METHODS
BOARD LAYOUT EXAMPLES: BALANCE AND IMPLIED MARGINS; TITLE PLACEMENT

SUPPORT MATERIALS BOARD

Following is a sketch of a typical support materials board. Such a board contains pictures and samples of the furniture and materials you have selected for your final design.

1. Balance the board.

2. Be consistent with the rest of your presentation.

3. Use white or off-white board or background (black or colored board will alter the effect of your color scheme).

4. If you have repeated elements, center them and add notes.

5. Good craftsmanship counts!

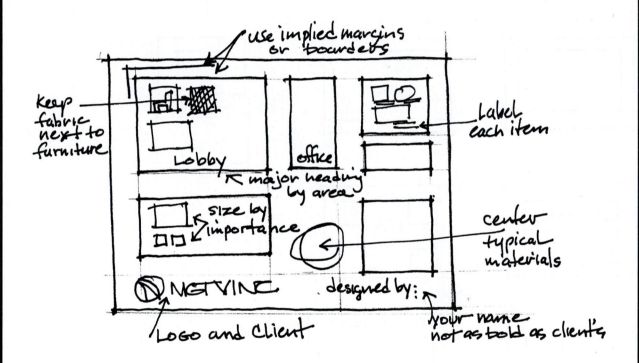

BIBLIOGRAPHY

Arends, Mark. *Interior Presentation Sketching for Architects and Designers.* New York: Van Nostrand Reinhold, 1990.

Ching, Francis D.K. *Architectural Graphics* (2nd Ed.). New York: Van Nostrand Reinhold, 1985.

Ching, Francis D.K. *Drawing: A Creative Process.* New York: Van Nostrand Reinhold, 1990.

Crowe, Norman, and Laseau, Paul. *Visual Notes for Architects and Designers.* New York: Wiley, 1986.

Doyle, Michael E. *Color Drawing: Design Drawing Skills and Techniques for Architects, Landscape Architects and Interior Designers* (2nd Ed.). New York: Wiley, 1999.

Herzberger, Erwin. *Freehand Drawing for Architects and Designers: Watercolor, Colored Pencil and Black and White Techniques.* New York: Watson-Guptill, 1996.

Laseau, Paul. *Graphic Thinking for Architects and Designers* (2nd Ed.). New York: Wiley, 1988.

Leach, Sid. *Techniques of Interior Design Rendering and Presentation.* New York: McGraw-Hill, 1978.

Lin, Mike W. *Drawing and Designing with Confidence.* New York: Wiley, 1997.

Lockard, William Kirby. *Design Drawing.* Eldridge, IA: Crisp Publications, 1993.

Lockard, William Kirby. *Drawing as a Means to Architecture* (2nd Ed.). Eldridge, IA: Crisp Publications, 1995.

Mitton, Maureen. *Interior Design Visual Presentation: A Guide to Graphics Models and Presentation Techniques.* New York: Wiley, 2004.

Oliver, Robert S. *The Complete Sketch.* New York: Van Nostrand Reinhold, 1989.

Wang, Thomas. *Pencil Sketching* (2nd Ed.). New York: Wiley, 2001.

White, Edward T. *Building Meaning: Analysis and Design for Image-Sensitive Projects.* Tucson, AZ: Architectural Media, 1995.

GLOSSARY/INDEX

architectural overlap, 20 A technique of overlapping a line at a corner to create a specific sketch character.

balance, 112 A characteristic of composition; a composition may be symmetrical or asymmetrical.

bubble flow diagram, 57–59 A diagram that involves five steps that evolve from simple bubbles to a preliminary, sketchy floor plan. It is a popular tool in the schematic phase of the design process and is useful for space planning and circulation.

chisel point, 9 An angled tip on a pencil point achieved by rubbing a sharpened point against a sandpaper block; can be used to draw a variety of line weights and qualities.

coloring book effect, 119 The result of trying to stay inside the lines when rendering and distinctly outlining all of the elements in a rigid manner.

composition study, 112–116 A series of quick perspective sketches that allow the designer to consider the best way to approach the final drawing of a particular space.

conceptual doodle/diagram, 51–52 A form of design graphic expressing a word, space, or action to be used to examine potential design solutions in the schematic phase of the design process combined into an involved series.

conceptual doodle/diagram perspective, 56 A quick, sketchy perspective drawing that illustrates action/reaction.

consistency, 20 Use of lines of the same weight or character as an exercise to develop control in drawings.

design drawing, 47 A visual language or shorthand used in the schematic or preliminary phase of the design process to help in the search for potential solutions to design problems.

drawing papers, 16–17 Papers suitable for drawing media, typically pencil.

drawing process, 81–88 Drawing steps used in conjunction with the design process.

drawing tools, 10–15 Various types of pencils, pens, and markers.

elements of a line, 20–23 Consistency, line weight, variation, and quality.

entourage, 131–146 Any and all elements of a drawing that humanize it and bring it to life, including trees, plants, people, and other items that add interest to the space and make the viewer believe that people inhabit it.

exterior sketch, 24 A freehand drawing done in open air.

eyeball perspective, 89 A sketchy perspective drawing without a mechanical grid that is commonly used for quick sketch-type communication.

figure studies, 145 Drawings of the human form.

final perspective, 78 A finished drawing that is the end result of the overlay method. Final perspectives may be loose and sketchy or photorealistic. They are often budgeted as an additional expense to the client.

fudge factor, 90 Artistic license that allows the artist to change or manipulate a part of a drawing to make it more believable.

full frame, 90 A perspective that extends to the full size of the paper.

gesture drawings, 145 Quick studies done in a sketchy style that help to develop a sense of the human form.

ground line, 63 The place in a perspective drawing where the visual plane meets the ground.

hand rendering, 119–121 Adding color, texture, tone, shadow, and character to a drawing; may be accomplished with marker, colored pencil, or any variety of media.

horizon line, 63 The imaginary line in a perspective drawing that is always at eye level.

image perspective, 65 An eyeball sketch-style drawing done in the preliminary phase of design that allows the

designer the opportunity to explore a wide array of options or ideas pertaining to said design.

interior sketch, 26 A freehand drawing done in any architectural interior space.

line, 19 The most basic element of a drawing.

line only, 3 A drawing using the qualities of line only: line weight, line variation, and line character.

line quality (character), 23 The most expressive lines, most commonly used for freeform or organic shapes, such as trees or plants.

line weight, 21 Visually, the thickness of a line: the thinner the line, the lighter the weight.

line weight variation, 5, 21, 37 The use of lines of different weights or thicknesses to add distinction to a drawing. Light weights are internal, medium weights define the form, and heavy weights define architectural features or establish base planes. A good drawing should contain a minimum of these three line weights.

loose sketch, 3–4 A fast freehand drawing.

loosening up, 17 Relaxing while drawing; can be done in a number of ways, including doing sketching exercises in a quick, freehand manner or by actually physically stretching.

macrocosm, 54, 55 The big picture or overview; the first thing tackled in a design problem.

mechanical perspective, 89 A perspective drawing that is completed with the use of mechanical tools.

microcosm, 54–55 The small details; considered last when tackling a design problem.

mind's eye, 2 One's perception of how something will look or turn out; how we see things inside our heads.

napkin art, 47, 89 A quick sketch (eyeball perspective) done on a napkin during a lunch meeting.

no lift, 146 A technique used to create a drawing in which the drawing tool is never lifted from the paper.

no look, 146 A technique used to create a drawing in which the artist never looks down at the paper while drawing.

one-point perspective, 89–99 A drawing that focuses on one wall as the rear elevation and allows for development of two other walls as well in the drawing.

overlay method, 111–121 The method by which one completes a final drawing, following the steps from composition study single-line blow-up to tone/shadow study to texture/materials study. The final step is to combine the aforementioned three studies into one final drawing.

penumbra, 32 The lighter aura that is part of a shadow.

perspective drawing, 63–64 The oldest and most popular method of design communication; drawn as if seeing from a particular place in a room. These drawings can appear realistic and believable.

picture plane, 64 In a perspective drawing, the plane in space that frames and defines the perspective that is drawn.

presentation, 149–151 The method used to display a design, including drawings to a client.

redundant line, 119 A line added to define a surface or plane that may already be defined by tone/shadow or texture.

scale figures, 54, 132–136 Human figures used in conceptual doodle/diagrams that help to establish a sense of scale and proportion.

shadow casting, 33 A characteristic of light that shows shadow from any form.

sketching, 33–36 A style or technique of freehand drawing that may be loose, tight, line only, or any combination of line, tone/shadow, or texture.

station point, 63 The point in a perspective drawing from which a person views the space or object.

still life studies, 138 Sketches of a single object or a variety of objects. Techniques include no lift, no look, tone/shadow, texture/materials, or a combination thereof.

stipple, 43–44 A series of dots, either small or of varying sizes, used in drawing to create tone, shadow, or texture.

support board, 151–152 A presentation board that facilitates one's design by presenting finish materials, fabrics, furniture, or other features in order to help the client understand the design concept.

texture, 39–44 The design element that helps define the character of a space. It occurs on every item and ranges from very smooth to very rough.

thumbnail sketch, 7 A small, quick sketch that is usually created at the beginning stages of the design process.

tight sketch, 3–4 A slower freehand drawing created using some mechanical tool(s).

tone and shadow, 31 Part of the overlay method, used to study light conditions.

tooth, 16 The texture or grain of paper; a paper with a heavier tooth has a more prominent texture.

tracing paper, 16 Paper that is translucent, available as parchment, vellum, or graphics paper.

two-point perspective, 101 A perspective drawing that focuses on the corner of a room or space, allowing the viewer to see only two walls of the space in a particular drawing; may also be an exterior of a building.

umbra, 32 The darker aura that is part of a shadow.

value scale, 31–32 A measure of light to dark, usually ranging from 0 (zero) for white to 10 for black.

vanishing point, 64 A point or points in a perspective drawing that are on the horizon line; the point or points at which all parallel lines converge.

vignette, 90 A sketch done with a level of simplicity that allows the viewer's eye to finish the picture as the four planes fade out equally on the paper.

wash, 12 A loose blend of media to cover a large area; usually associated with watercolor painting.